DESIGN FOR INQUIRY

Instructional Theory
Research
and Practice
in Art Education

Elizabeth Manley Delacruz

Department of Art Education • University of Illinois

National Art Education Association
1916 Association Drive • Reston, Virginia 20191-1590

Curr
N
85
D44
1997

About the Author

Elizabeth Delacruz is an Associate Professor of Art Education at the University of Illinois, Urbana, Illinois.

About the *Point of View* Series

The purpose of the Point of View Series is to focus attention on and promote art programs that include a comprehensive approach to art learning, including the interpretation of and viewpoints on the components of the NAEA goals for quality art education.

The authors were selected because of their knowledge of the topic. While their points of view may differ from others in the field, it is NAEA's mission to advance discussion, examination, and reflection on the content of art education.

About NAEA

Founded in 1947, the National Art Education Association (NAEA) is the largest professional art education association in the world. Membership includes elementary and secondary teachers, art administrators, museum educators, arts council staff, and university professors from throughout the United States and several foreign countries. NAEA's mission is to advance art education through professional development, service, advancement of knowledge, and leadership.

About the Cover

The Banjo Lesson, 1893, by Henry Ossawa Tanner (1859-1937), Oil on Canvas (49" x 35½"). Permission to use is granted by the Hampton University Museum, Hampton, Virginia

ISBN 0-937652-98-9

This book

is dedicated

in loving memory

to my brother

John Manley

who died on

December 9, 1991

of complications

from AIDS

Acknowledgments

My warmest heartfelt thanks go to those who read and commented on earlier drafts of this manuscript: Marianna Adams, National Gallery of Art; Sarah Cartiff, Urbana Middle School; Mary Erickson, University of Arizona; Susan Gleason, Urbana High School; Don Gruber, Clinton High School; E. Louis Lankford, Ohio State University; Hector Munoz, Northern Illinois University; Frank Phillips, Council of Chief State School Officers; Valerie Piacenza, Barrington Middle School; Deborah Smith-Shank, Northern Illinois University; Kimm Stastny, Adlai E. Stevenson High School; Christine Thompson, University of Illinois; Mike Vandeleur, Waubonsie Valley High School; and Linda Willis-Fisher, Illinois State University. Finally, I want to acknowledge my longstanding mentor and friend, George Hardiman, for his good humor, wise counsel, and moral support over the last 15 years.

Contents

– 1 –
Some Conceptions
of Teaching

*The good news and the bad news is that public
education is a work in progress (Dawson, 1984).*

- *Teaching is the way human beings define and convey to one another the
 meaning and methods of living.* To educate is both to preserve and to
 change the meaning of human experience.

- *Teaching is an activity aimed at the achievement of learning.* It is prac-
 ticed in such a manner as to respect students' intellectual integrity and
 capacity for independent judgment (Scheffler, 1965). For Israel Schef-
 fler, this characterization is important for two reasons: "First, it brings
 out the *intentional* [italics added] nature of teaching, the fact that teach-
 ing is a distinctive goal-oriented activity, rather than simply a patterned
 sequence of behavioral steps executed by the teacher. Secondly, it differ-
 entiates the activity of the teacher from such other activities as propa-
 ganda, conditioning, suggestion, and indoctrination, which are aimed at
 modifying the person but strive at all costs to avoid a genuine engage-
 ment of his judgement on underlying issues" (1965, p. 131).

- *Teaching occurs only when students learn.* Intentionality by itself is not
 sufficient. Teaching cannot achieve its goals if students are not partici-
 pating. Teaching is recognized when changes in students' thinking have
 actually taken place. But thinking is covert and personal. So teachers
 must rely on certain indicators — communications about insights, sym-
 bolic representations of the world, and particular demonstrations of un-
 derstanding. The value of teaching is seen in terms of what students
 actually do as a result of teachers' efforts.

- *Teachers learn and learners teach.* Lee Shulman (1986) defines teaching
 as an activity involving teachers and students jointly. He sees teachers

and students both as individuals and as members of multiple larger groups. Like their students, teachers are changed by the educative event. As students act upon and make sense of instructional programs, they change the meaning of those programs. Teaching, then, is the achievement of shared meaning and resulting in reciprocal changes in behaviors, thoughts, and attitudes. Using educative materials of the curriculum, teachers and students aim at a congruence of meaning in a back-and-forth communication.

- *Teaching occurs in a context that characterizes both method and content.* Teaching and learning, teachers and students, occupy a unique place in the larger community, and within the society at large, but their space, the classroom, is also seen as a community in itself. The dimensions of classroom life, intentional and latent, flavor learning experiences and ultimately student knowledge about the larger world.

- *Finally, the enterprise of education is a big business.* As of 1988, there were approximately 108,000 public and private schools in the United States, all striving to meet individual, community, and societal goals (National Endowment for the Arts, 1988). Everyone has a vested interest in education, and *everyone has something to say about teachers.*

Teaching then is a complex form of public service that requires high levels of formal knowledge for successful performance. Teachers develop and utilize substantial knowledge about their content areas; about students' intellectual, psychological, social, and aesthetic development; and about schooling, including institutional goals, needs, influences, and limitations (Shulman, 1986). Thomas Green (1974) identifies teacher activities as logical acts (amassing information, defining, explaining, concluding, comparing, inferring), strategic acts (planning, motivating, counseling, evaluating, and disciplining), and institutional acts (budgeting, monitoring, reporting, and patrolling).

Teachers' work extends well beyond the classroom. In addition to sponsoring after-school student activities, grading and preparing lessons at home, and erecting displays of student work, teachers confer with other teachers and community members about school matters and attend numerous meetings, seminars, workshops, and conferences. Teachers also spend a lot of time reading, both within and outside their areas of specialization (Delamont, 1976). Finally, many teachers have a second job because the profession just is not well compensated in many school districts. Although one could argue that second jobs are not part of the teaching profession, they are necessary work that allow many teachers to remain in public service.

Art Teaching

Teaching art is like no other work in the schools. Art teachers teach, for the most part, without published textbooks, workbooks or standardized tests and measurements and with minimal instructional resources. Most of a school's art budget goes to the purchase of consumables, tools, and equipment. The availability, quality, and condition of these varies significantly from school to school. Some art teachers have a room of their own. Some share their space with other teachers. And some art teachers teach from a cart, often serving three or more schools. Students within art classes vary considerably in their attitudes and abilities. Many come to class with minimal knowledge and skill in art. Others come with vast artistic experience, talent, and interest.

The differences between teaching art at the high school level and teaching art in the elementary schools are vast. Yet there are certain commonalities. Studies of curriculum guides (Wilson, 1988), surveys of teachers (Chapman, 1982), and case studies (Stokrocki, 1990a; Szekely, 1988) indicate that art teachers at any level spend most of our their time teaching about materials and processes associated with the production of art and that they center their instruction around the learning of selected design concepts (the characteristics of line, color theory, composition and unity, etc.). Art teachers rely primarily on the apprenticeship method of instruction, which is modeling (or demonstrating) with guidance (or evaluative feedback). Many art teachers view themselves as artists, making art both during and after school hours. Some art teachers have active and successful second careers as artists, exhibiting and selling their art privately or in shows, fairs, and galleries.

Art teachers are amazingly resilient, optimistic, and resourceful. They hold idealistic notions that the kinds of unique, transformative, deeply personal experiences they provide will enhance their students' lives profoundly and immeasurably. For the most part, art teachers conduct their own research and create and design their own instructional programs — thankful that they are not limited to someone else's ideas. They produce an incredible array of imaginatively designed instructional resources, promote art programs with great finesse, and erect and dismantle innumerable eye-dazzling exhibitions of student artworks — anticipating that student works will speak well for the art programs. Most art teachers like their work, despite its demands and ever mounting problems and hold firm to the belief that teaching art is a worthwhile and meaningful profession. In fact, 89% of them would recommend art teaching as a career to others, despite its frustrations and difficulties (Leonhard, 1991).

Instruction

Almost all education professionals have a theory of instruction, some core concepts and principles that guide their professional endeavors. A theory of instruction is a set of interrelated propositions about the teaching and learning that takes place in the classroom, focusing in particular on the teacher's activities and methods. A fundamental difference between curriculum and instruction has been asserted to distinguish *what* is taught (curriculum) from *how* it is taught (instruction). Theories of instruction propose *how* to accomplish our educative goals. But instruction without content is impossible, or in this case rather artless. Although the distinction between content and method is useful in that it allows separate examinations of certain aspects of teaching, it is also misleading as method and content are really part of the same dynamic. They are forever intertwined in a complex matrix of thought, purpose, and action. In this view, instruction *is* content. The way an individual teaches informs students not only what he or she thinks about art but also what he or she thinks about them.

The final test of a theory is the extent to which it explains what it sets out to explain, and the test of that explanation lies in its ability to predict what might happen next (Lamm, 1976). What are art teachers trying to predict? They predict that, as a result of their interventions, students will come to understand art and its monumental potential for the creation and contemplation of meaning and their lives will be transformed and enhanced as a result of this undertaking. This is difficult stuff to verify by observation alone, so many art teachers operate on a sense of faith and commitment — that is, if they do certain things, good things will happen. A theory is really no more than a storehouse of hypotheses, or best guesses, in need of some sort of confirmation (Lamm, 1976). And so art teachers, in various ways, teach art to students and observe the results of their decisions and methods, making modifications as they embark on a path of exploration and discovery.

The distinction between instructional theory and instructional practice is an academic one. Instructional practice is theory in action. However, it is important to distinguish talk about instruction *as it is,* from talk about instruction *as it ought to be.* What teachers say they *should do* and what they *actually do* in the classroom may be strangely different things. Basic educational research attempts to answer difficult questions about teaching and learning — some of this research finds immediate practical applications to classroom settings, some merely stimulates further inquiry. Such inquiry is necessary for the growth of knowledge and the advancement of the profession. But

research *in* typical, fully occupied public school art classes is scant at this time, much to the frustration of art teachers. In the view of many researchers, basic research requires controlled settings where fundamental processes may be examined in painstaking detail. Even qualitative researchers have to isolate and focus on particular aspects of the teaching-learning complex to answer highly selective questions. Regular art classes are often too quickly paced, too chaotic, and too difficult to manage for many researchers. Nevertheless, research on teaching and learning is useful to instructional theory, design, and practice only insofar as it takes into account the *conditions of teaching*.

Early in this century, theories of instruction were derived from psychological and medical theories. By mid-century, linguistics, ethnography, and cultural psychology informed instructional theory. Instructional theories have also looked to a branch of computer science concerned with artificial intelligence (Bruer, 1994; Engleman & Carmine, 1982). Currently theories of the brain, its neurophysiology and its functioning, information processing theories, social interaction theories, theories of the personality, and critical social theory contribute to the development of contradictory instructional theories. Contemporary theories of instruction are, by necessity and by design, eclectic.

Psychology and the Development of a Theory of Learning

Educational psychology has been the primary source of information about instructional design and practice for the past 50 years. But within the disciplines informing educational psychology, competing conceptions about teaching and learning have suggested different instructional programs. *Behavioral psychologists* such as B. F. Skinner argued that teaching occurred by exposing students to appropriate environmental stimuli and rewarding them when they made the proper responses (Bruer, 1994). Learning was seen only in terms of observable behaviors, and learners' behaviors were conditioned (determined) through specific reinforcements (presumably positive). The use of behavioral objectives by teachers is a longstanding outgrowth of this interest in describing learning only in terms of what we can observe.

In contrast, *cognitive developmental theorists* Jean Piaget, L. S. Vygotsky, Jerome Bruner, and Robert Gagne set out to disclose those hidden mental processes by which the learner approaches specific problems. Cognitivists argue that a science of how we perceive, remember, learn, plan, and reason is not only possible but necessary to instructional design (Bruer, 1994).

At the same time, a third strong movement in psychology, *humanism*, gained the favor of educators. Spurred on by the theories and writings of Carl Rogers and Abraham Maslow, humanistic psychology concerned itself with the development of the personality, and the fulfillment of the basic physical, emotional and psychosocial needs of the individual. Although humanistic psychology offered a compelling alternative conception of instructional processes, humanistic interests have remained on the periphery in instructional theory and design.

The ascent of cognitivism in educational theory. Behavioristic tenets gradually fell out of favor as research and theories in cognitive developmental psychology gained prominence. Jean Piaget's "genetic epistemology" (the study of the growth of knowledge in humans) was particularly influential. Piaget believed that human intellectual growth occurred naturally and could be mapped hierarchically. In Piaget's stage-age framework, development toward higher levels of intelligence was described as universal, innate, and invariant. The purpose of schooling, from a Piagetian view, was to facilitate natural development. Teachers needed to become aware of students' readiness for particular kinds of intellectual encounters in order to provide an effective education. Benjamin Bloom's landmark *Taxonomy of Educational Objectives* (1956) in the cognitive domain, linked students' intellectual abilities and instructional programming. In Bloom's framework, educational activities associated with thinking, remembering, problem solving, and creating were organized hierarchically. At about the same time, Victor Lowenfeld proposed a hierarchical age-stage model of artistic development. In Lowenfeld's model, knowing the stages of children's creative and mental growth in relation to their general development allowed teachers to motivate them toward their artistic potential. Lowenfeld's widely popular *Creative and Mental Growth,* now in its fifth edition, shaped art education instructional practice for the next forty years. More recently, Michael Parsons has offered a Piaget-inspired theory of aesthetic reasoning (1987). Parsons's model provides a hierarchical stage-age framework for understanding how individuals come to understand and appreciate art.

The movement away from developmental determinism in art education instructional theory was forecasted by Brent and Marjorie Wilson, who were engaged in cross-cultural studies of children's drawings in the late 1970s and early 1980s. The Wilsons maintained that Piaget-inspired theories of universal cognitive development were inaccurate, inadequate, and incomplete as guides for informing teachers about children's artistic development (1981). They further argued that accounts of children's developmental stages seriously misinform and obscure more than they reveal about children's drawings.

Contemporary theories of cognitive development describe mental processes as more complex and more interactive than Piagetian models. In his studies of novice and experts' progression toward mastery in specific disciplines, David Henry Feldman has found that learners can reside at several intellectual stages simultaneously, that they skip stages and regress to earlier stages, and that most intellectual development is non-universal— that is, it requires formal, systematic, sustained instruction for development (1985). In this view, Feldman suggests an apprenticeship model for art teaching, wherein teachers act as disciplinary experts and mentors to students. Howard Gardner proposes a multidimensional model of human intelligence (1993). Gardner asserts that traditional unitary models of cognition incorrectly limit definitions of intelligence to linguistic and logical-mathematical abilities. Other forms of intelligence, in Gardner's view, include musical intelligence, spatial intelligence, bodily-kinaesthetic intelligence, and two forms of personal intelligence — intrapersonal intelligence and interpersonal intelligence. Gardner observes that schools, in their preoccupation with verbal-analytical modes of knowing, severely limit the intellectual potential of students, and, ultimately, of the society as a whole.

The implications of these changes in thinking about human intellectual and artistic development are important for art teaching. As definitions of cognition are broadened to include artistic and aesthetic intelligence, the cognitive function of art, and its role in human development, are made more cogent. Further, the role of the art teacher, as a specialist with extensive knowledge and understanding about both art and teaching, shifts dramatically. Art teachers are no longer thought of as non-interventionists, ready to stimulate students' creative and mental growth but careful not to intrude too heavily in students' natural development. Rather, they are expected to interact directly and purposefully with students to shape and alter their ways of thinking about art.

Communication theory and information science. By mid-century, linguists were arguing that humans' ability to speak and understand language results from the transformation of deeply embedded mental symbol structures through a set of equally deeply embedded mental processes (which Bruer [1994] refers to as rules or operations). Psychology, in its attempt to study and explain those deep structures and rules for transforming mental symbols, would become a science of the mind (Bruer, 1994). At the same time, psychologists interested in simulating human thinking in computers began to look at short- and long-term memory, the capacities of information channels, and problem-solving networks (Bruer, 1994). These scientists demonstrated that both computers and the human mind operated by processing symbols through complex but describable operations (Bruer, 1994). As cognitive scientists studied

both novices' and experts' knowledge and strategies in specific domains of knowledge, it became clear that certain strategies for processing and transforming information and solving problems were more effective than others.

Cognitive scientists now think of mental processes as *cognitive architectures*, built-in mental structures that allow our minds to build and execute programs in specific domains of knowledge (Bruer, 1994). Learners rely on temporary "mental scaffolds" for transforming information in various disciplines. As old scaffolds no longer work they must be dismantled and new scaffolds constructed with the help of mentors and teachers (Bruer, 1994). The concern for teachers is *how* to teach effective cognitive strategies for handling problems and new information in various domains of knowledge, as well as *what* facts to teach about those domains. The instructional approach best suited to this task is, again, the *apprenticeship model* or coaching model — experts or more competent peers demonstrate complex processes and guide novices as they learn these processes (Bruer, 1994).

The movement toward cultural psychology. Theories about learning and the functions of the mind have moved from a general view of information processing as a content-free, generic process to one where content, context, and expectations are now believed to be central. This shift has led to an interest in the motivations and meanings that a learner invests and extracts from educative experiences (Sullivan, 1992). Early thinking along these lines is found in the writings of John Dewey and his followers, who viewed learning as the mediation of specific experiences embedded in a larger continuum of experience, and education as *a social effort*; and in the work of L. S. Vygotsky, who believed that cognitive development occurred primarily through the medium of language *and culture.*

L. S. Vygotsky was a Russian developmental psychologist who died at the age of 37 in 1934. Vygotsky's writings were officially banned for two decades after their original publication because they were in opposition to official Soviet thinking. They were finally republished in 1956 and translated into English in 1962. Vygotsky, contrary to Piaget, contended that language and thought, together, created a cognitive tool for human development, and that human knowledge and thought were essentially *cultural*, deriving their distinctive properties from the nature of social activity, language, discourse, and other cultural forms. In Vygotsky's theory, children's understanding is shaped not only through adaptive encounters with the physical world but also through social interactions with people in relation to that world — a world not merely physical and apprehended by the senses, but interpreted and mediated through language and culture (Wertsch, 1985). According to Vygotsky's

theory, the teacher is both the catalyst through which children move to new and higher levels of understanding, and the *filter* through which children come to know the world.

Current theories about the growth of knowledge have moved toward Vygotsky's notion of knowledge as a socially constructed phenomenon, and *dialogue, or conversations with children*, as the primary mode of instruction. Vygotsky rejected the concept that instruction must match the child's present level of development. Instruction, rather than exercising developmental skills already acquired and used independently by the child, should be based on cognitive skills in the process of forming. The centrality of instruction in the cognitive development of the individual is seen most clearly in what Vygotsky called the "zone of proximal development," which he defined as "the distance between the actual developmental level as determined by independent problem solving and the level of potential development as determined problem solving under adult guidance or in collaboration with more competent peers (Vygotsky, 1978, cited in Edwards & Mercer, 1987, p. 23).

Theories of social interaction have linked the study of the development of knowledge in individuals to the study of cultural values, patterns, and customs, including the development and use of language in social contexts. The modes of thinking, reasoning, and problem solving acquired by the child are derived from cultural norms as transmitted by social agents such as adults (Fielding, 1989). The functions of educational institutions is seen, in this analysis, as the conservators and purveyors of cultural knowledge and values. The implications of such a theory for art teaching are clear to Fielding: "For significant learning in the visual arts to occur in the classroom, the teacher needs to become involved in the inculcation of the child into the thinking processes and conceptual organization of art" (Fielding, p. 47). In other words, art teachers function to model not only disciplinary knowledge and strategies for transforming information; they pass on deeply embedded cultural beliefs and values about art.

Radical pedagogies and social reconstructionism. Interest in the social and political parameters of teaching and learning, set in opposition to "traditional" or "mainstream" practices and theories, have been of great concern in the writings of reconceptualists, feminists, and the social reconstructionists in education (Giroux, Penna, & Pinar, 1981; Gore, 1993). These approaches have gone by various names, "progressive education," "feminist pedagogy," "liberatory pedagogy," "radical teaching," and "critical pedagogy." The term *pedagogy*, Jennifer Gore explains, refers to the science of teaching children (1993). It is commonly used interchangeably with the terms *teaching* or *in-*

struction. What makes these instructional approaches *radical* is their call for a fundamental transformation of educational structures and processes. What makes them *critical* is their critique of instructional processes and regimens that oppress and devalue particular individuals and groups in our society. Although radical pedagogies have promoted differing agendas, what unites them a focus on the politics of school processes, an interest in the broader political and social contexts in which schools are situated, and a concern for how and in whose interests knowledge and values are transmitted and reproduced in educational institutions (Gore, 1993).

In art education, radical theories of teaching reflect these interests. Art teachers and teacher educators receive ever increasing messages to be cognizant of gender and ethnic differences and issues in the classroom (Collins & Sandell 1984; Freedman, 1994; Grigsby, 1977; Hart, 1991; McFee & Degge, 1977; Sherman, 1982, Zimmerman, 1990; Twiggs, 1990); to be self-aware of racist, unethical, and entrenched patterns of instructional practice (Ambush, 1993; Chalmers, 1992; Congdon, 1989; Hicks, 1994; Wasson, Stuhr, & Petrovich-Mwaniki, 1990); and to interact with students in ways that empower them to deal effectively with the pervasive, inequitable social conditions in our society (Collins, 1995; Hicks, 1990; Sandell, 1991). The primary concern is not simply with which instructional methods work best for the delivery of content but also with how teachers and schools perpetuate patterns of social injustice through inappropriate treatment of students on the basis of their ethnicity, gender, or social class, and through the transmission or reproduction of unauthentic truths or favored forms of knowledge (Bersson, 1987; Blandy & Congdon, 1987; Hamblen, 1988).

Redefining Teaching: Inquiry for the Third Millennium

Theories and debates over the locus of knowledge; studies of the processes by which knowledge is formed, shared, and canonized in instructional programs; and issues relating to the ethics and relevance of instructional theory, research, and practice characterize contemporary discourse about teaching. Schools of thought have converged in recent years in fundamental ways: Interdisciplinary inquiry bridges thinking in related fields; many researchers have disengaged from the search for a single "theory of everything" (Feynman, 1988); and, as *the millennium* emerges as a metaphor for the future, a new focus on the problems of living together on this planet has captured our imagination (Nasbitt & Aburdene, 1990).

Talk about instruction as if it were something that occurs on its own, Dewey warns, is like supposing one could eat without food. Such a distinction is only possible in thought or discourse, or in academia where the rich murky realities of the lived world (in this case, the world of classroom life) can be bracketed out temporarily. The contents of instructional practice are not only the curricular areas in question (art, history, science...), but the people and the contexts through which instructional goals and processes are realized. It is here, with particular teachers in particular situations, that talk about instruction becomes meaningful.

— 2 —
Research on Teaching

Teaching is an art that has no appeal
when it is described only in words.
(Margaret Mead cited in Davies, 1981, p. 4)

Research on teaching has taken many forms since its inception in the early 1900s, but three fundamental interests persist: interest in teacher characteristics and behaviors, interest in the manner in which students learn with regard to particular instructional strategies, and interest in the social spaces created by teachers and students. Collectively, research findings make their way into instructional programs, curriculum reform initiatives, teacher performance measurement systems, student assessment practices, state and local educational policies and mandates, and university preservice education programs. Lee Shulman (1986) believes that combining separate accounts of teaching from distinct areas of research can help fashion a broader picture of teaching.

Teacher Effectiveness

Many studies conducted over the last 30 years involved the observation of specific teaching behaviors and linked variations in what teachers do to variations in the performance, measured achievement, or attitudes of students. These *process-product studies* (teaching *processes* led to certain outcomes or *products)* have come to be known as "teacher-effectiveness" studies and have resulted in the development and proliferation of numerous prescriptions for practice (Shulman, 1986). Propositions about what constitutes good practice, in turn, have formed the basis for the training, development, and evaluation of teachers (Shulman, 1986). These propositions often deal with generic instructional behavior — use of levels of questions, wait-time, responses to student participation in classroom discussions, the type and frequency of praise or criticism — and with classroom management behaviors — establishment of rules and procedures, allocations of turns and privileges, and responses to misbehavior (Shulman, 1986).

Although teacher-effectiveness studies brought about a greater awareness of many aspects of teaching previously overlooked, they resulted in a limited conception of the parameters of good teaching. Prescriptions and policies for good practice have been, in many cases, based on teaching behaviors that brought about increases in student standardized achievement test scores (Shulman, 1986). For Jere Brophy (1988), *teacher effectiveness* is a much broader concept, having meaning only in reference to other highly valued educational goals. These goals include not only student achievement test gains, but also the development of student interest in subject matter, attention to the personal adjustment and mental health of individual students, and the development of a prosocial, cooperative group atmosphere in the classroom (Brophy, 1988).

Competency-based teacher education programs based on teacher-effectiveness studies are reemerging now at state departments of education as reformed teacher certification programs, beginning teacher programs, and teacher performance evaluation systems. These programs affect decisions about teacher licensure, tenure, merit, promotions, and salaries. Brophy (1988) observes a returning emphasis on more authoritarian educational structures, in which students are expected to work hard, behave appropriately, and master difficult material. This coincides with an interest in making subject matter more rigorous and more substantive and in promoting highly directive teaching methods associated with the organization and presentation of instructional material.

Interestingly, this kind of thinking is complemented with an emerging interest in student cognition, inquiry, discovery, and collaboration and with student-initiated learning, higher order thinking, critical reasoning, and metacognitive skills — outcomes rarely measured in standardized tests. These interests have led to the development and support of indirect teaching methods: cooperative learning, inquiry training, discussion, and independent study.

Teacher Knowledge, Thinking, Planning, and Decision Making

Shulman (1986) distinguishes among three kinds of teacher knowledge:

- *Subject matter knowledge* is that comprehension of the subject appropriate to a content specialist in the domain.

- *Pedagogical knowledge* refers to the understanding of how particular topics, subject matter principles, and strategies are likely to be both un-

derstood and misunderstood, remembered and forgotten by learners. Knowledge about children and the psychology of learning is essential to pedagogical knowledge.

* *Curricular knowledge* is familiarity with the manner in which subject matter is organized for instruction.

Research suggests that teachers' expertise and experience greatly affects their decisions and plans (Shulman, 1986) and that experienced teachers' plans are found to be more in-depth and more specific about subject matter and organization than inexperienced teachers (Calderhead, 1984). But, according to Shulman, research on teachers' knowledge, subject-matter understanding, and representation in the classroom is in its infancy and findings are inconsistent.

Teacher planning is defined as all activities, physical and mental, that engage teachers as they prepare for teaching. It encompasses a wide range of efforts and occurs both within and outside the school. Teachers' mental planning concerns mostly the subject matter to be covered, available resources, student abilities, personalities, reactions to subject matter, and lesson requirements. Teachers' mental planning includes thinking about the development of instructional materials, decisions on how to deal with particular student difficulties, and mental rehearsals of explanations regarding lessons. Teachers' planning also includes participating in school meetings; developing mission statements; conferring with colleagues; consulting with parents; taking additional course work; and simply *thinking* about lessons, topics, students, and materials. Finally, teachers' planning and preparation for instruction includes reviewing, selecting, and creating instructional resources; developing outlines for instruction; and reviewing records of student work. Recent investigations indicate that *planning involves a great deal of teachers' time, concern, and effort outside work hours, contrary to the misconception that teaching is a 9-to-4 job and dispelling the myth that teachers do not work as many hours as professionals in other fields* (Calderhead, 1984).

Research on teachers' thinking, both before and during instruction, indicates that teachers make their most important decisions prior to instruction and at the beginning of the academic year, rather than making decisions after contact with students or forming instructional programs collaboratively with students. Decisions are based on teachers' views about subject matter, their prior beliefs about students, and their knowledge of available resources. Studies also indicate that elementary teachers are more likely than secondary teachers to entrust long-term planning to the textbooks (Calderhead, 1984).

Implementing Plans: Thinking on Your Feet

Studies of teachers' decision making during instruction indicates that teachers make hundreds of instructionally significant decisions in a given day. Teachers' reports of their thoughts while teaching indicate that they attend primarily to their plan, which they conceptualize as a mental "script" of how things should be going. A common script used during the interactive phase of teaching is one of structuring, soliciting, responding, and reacting (Shavelson & Stern, 1981). Teachers focus on cues from the classroom environment, most importantly, students' levels of attention and performance. Decisions based on these cues are influenced by teachers' preconceptions about students (Shavelson & Stern, 1981), teachers' thresholds for disruption, and their thinking on whether the instruction or activity itself is the reason for lack of acceptable student interest or performance (Calderhead, 1984). If waning interest is attributed to scheduling (it's almost lunchtime or the period is about to end), teachers ignore these cues. More serious problems lead teachers to consider alternative actions: stopping the activity and starting another, attempting to relate the activity to the known interests of students, discussing with students why they are losing interest, or stressing the importance of the lesson.

Teachers' decisions in the classroom are rendered quickly as there is little opportunity for substantive reflection. Teachers monitor the classroom as a way to evaluate classroom routines. Their routines are based on certain broadly held and applied principles including:

- *Compensation* — attempting to compensate the alleged "have-nots" in their classes by favoring shy or low-achieving students.

- *Strategic leniency* — going easier on students needing special attention.

- *Power sharing* — dispensing teacher authority in informal ways.

- *Progressive checking* — monitoring the progress of low-ability students during interactions and activities.

- *Suppressing emotions* — wherein teachers systematically suppress their own emotional reactions to students and events in the classroom. (Shavelson & Stern, 1981).

As teachers gain experience and anticipate certain interactions, their classroom decisions become part of the regular routine, which smoothes out over time (Calderhead, 1984).

The pitfalls of overplanning. Studies (e.g., Calderhead, 1984; Doyle, 1986) indicate that student learning may decline when teachers with well-struc-

tured plans put too great an emphasis on subject matter and fail to take into account students' individual differences and interests. Further studies (e.g., McCutcheon, 1981) indicate that when lessons do not go as planned, teachers think more about their students (Why didn't they get it? Why weren't they interested?). Gail McCutcheon (1981) recommends that teachers be sensitive to the teaching-learning process. She describes plans as "maps": They help teachers as they navigate through their routes, but teachers should always be ready to take advantages of detours. Successful teachers are as oriented toward student competencies and difficulties as they are toward subject matter, and their plans indicate this orientation (Calderhead, 1984).

Implementing educational reform initiatives: The practicality ethic. Research on teachers' responses to new materials or instructional approaches indicates that teachers are concerned primarily with the subject matter to be covered and whether the materials and methods are appropriate and interesting to their students. Congruence with the teacher's normal style of teaching, with the types of students in the program, and with the contexts in which he or she is working affect the degree of incorporation of curriculum innovations (Doyle, 1986). Abstract ideas or general principles prescribed as improvements are less likely to be adopted by teachers, especially when they are mandated "top-down" by administrators or policy makers. Prescribed innovations not understood by teachers are also likely to be met with resistance. The time, effort, and money required to implement the innovation are given careful consideration by teachers, as they weigh costs against perceived potential benefits to student learning or interest. Teacher's decisions about whether to incorporate new materials or approaches are made on the basis of their knowledge of what works in the classroom. Doyle (1986) calls this the *practicality ethic.*

McLaughlin and Thomas (1985) found that educational reform initiatives are not likely to be implemented or retained by schools without substantive involvement on the part of teachers in the planning and development of reforms. Moreover, reform efforts are unlikely to be sustained in schools without substantive continued institutional support beyond the introduction of the innovation. This includes staff development, release time for planning, sustained leadership, and sufficient instructional resources.

Teacher Self-Appraisals and School Ethos

A teacher's sense of self-efficacy (a belief in his or her own power to achieve instructional goals) is found to be subject and situation specific rather than generic (Ashton & Webb, 1986). Teachers vary in their effectiveness from

one teaching task to another. A teacher may be a skillful discussion leader but a poor lecturer. Most teachers know their strengths and weaknesses (Ashton & Webb, 1986). In their extensive multischool study of teachers, Patricia Ashton and Rodman Webb concluded that *a teacher's positive sense of self-efficacy is dependent on school organization, leadership, and ethos. Teacher efficacy can be worn down by poor working conditions or unhealthy school environmental factors.*

The degree to which teachers are participants in school governance is a significant factor in their sense of efficacy. Ashton and Webb found that teachers' sense of efficacy increased when teachers planned together and set readily attainable goals for themselves and their students. *Proximal goal setting* means establishing short-term steps toward long-term (*distal*) goals, making sure that proximal goals are not trivial. Ashton and Webb also found that in schools supporting high-efficacy teachers, principals viewed teachers as co-workers in the school, established clear and open channels of communication, and deferred decision making to teachers whenever appropriate. Teaming, subject area departmentalization, and collegial peer relations also contributed to high teacher self-efficacy. These are critical findings because, as Ashton and Webb discovered, *a teacher's high sense of self-efficacy is strongly related to student success in the classroom.*

Research on Teaching in Art Education

Studies of art teaching have been somewhat limited due to an emphasis on the artistic and aesthetic development of children, a preoccupation with the development of a viable rationale for art education, and an emphasis on curriculum theorizing and reform.

Looking for Connoisseurship: The Missing Link

As far back as the 1960s art education researchers were interested in determining the degree to which art educational programs fostered "art appreciation" (as was commonly claimed at the time). Studies focused on the relationships between art instruction and student ability to discern, describe, and interpret the salient features and qualities in artworks. These abilities were believed to be evidence of sensitivity to artistic form and meaning (an intended outcome of art education). But when art educators went looking for evidence of this outcome in typical art classes, they found that students were

largely unable to respond intelligibly to artworks without substantive teacher interventions. That is, without instructional programs specifically designed to foster the skills of appreciation and the articulation of critical responses to art, such skills were lacking in students, regardless of years of art classes taken (Day, 1976; Wilson, 1966, 1972).

Interest in students' ability to describe and interpret art motivated more extensive studies in the 1970s and 1980s, resulting in the elaboration and refinement of generalizations about the manner in which student understanding of artworks is related to specific teacher behaviors and instructional decisions. Studies indicate that art teachers' verbalizations impact student responses to art (Koroscik, 1985); that prior knowledge, presentation time, and task demands affect visual art processing by students (Koroscik, 1982); and that the manner in which artworks are grouped for display and student study affect what students think about them (Koroscik, Short, Stavropoulos, & Fortin, 1992). The combined effects of exposure, counter-attitudinal advocacy, and art criticism methodology have been found to positively influence art students' development of positive affect toward artworks (Hollingsworth, 1983). These studies have led to a much more complex picture of the practice of teaching art than previously thought.

A handful of studies of the effects on students' art making of particular approaches to instructional effects , have been conducted in K-12 classrooms, and appeared in professional publications (Armstrong, 1986; Brewer & Colbert, 1992). These studies suggest that the inclusion of more direct teaching methods — lecturing, demonstrating, showing slides and reproductions of other artists' works, having students copy from models and exemplars, and using directive questioning strategies — have a positive effect on the quality of student studio work. Recent writings on indirect teaching methods (Socratic dialogue, discussion groups, cooperative learning, inquiry training, peer-teaching, self-assessment, etc.) and their impact on student artwork offer other provocative models for art teaching (Addiss & Erickson, 1993; Hagaman, 1992; Lankford, 1992; Sandell, 1991; Stout, 1992).

What Do Art Teachers Do in the Classrooms?

During the past three decades a number of art educators and arts agencies have asked this question in an attempt to get a sense of what art teachers do in the classrooms. Central to this question was an underlying realization that despite years of advocacy for a multifaceted program of art instruction, art teachers were concentrating their instructional efforts on the teaching of design concepts, media, and processes. Laura Chapman (1982) looked broadly

at art classrooms and surmised that the teaching of art was dominated by hands-on activities, with little attention to art history and appreciation. Enid Zimmerman (1984), summarizing findings from the 1976 National Assessment of Education Programs art assessment, similarly reported that students taking art classes were no more knowledgeable about art history and appreciation than students who had not taken art courses. Surveys of art teachers conducted at that time indicated that art history instruction was a low priority and was not included in their art programs (Zimmerman, 1984). Brent Wilson's (1988) analysis of the contents of art curriculum guidelines around the United States confirmed this finding.

The exclusive focus on studio instruction may be changing in art teaching. In a recent survey of elementary art teachers conducted by Louis Lankford and Sandra Mims (1995), teachers reported that they devote 65% of their instructional time to studio production, 16% to art history, 10% to art criticism, and 9% to aesthetics. Interestingly, these same teachers reported that 89% of their budgets were used to purchase consumables (paint, paper, clay, etc.), leaving only 11% for instructional resources (books, prints, slides, and videos). Knowing how inadequate art budgets are in the public schools and how expensive instructional resources are, one wonders how much and what kind of nonstudio instruction really occurs in these classrooms.

James Gray and Ron MacGregor undertook a detailed study of art teaching practices in the United States, Canada, and Australia from 1986-1990 (Gray, 1992). Gray and MacGregor found that art teachers were focused primarily on studio instruction and that they varied their approaches to instruction, from tightly teacher-centered approaches to indirect approaches. Gray and MacGregor described art teachers' commonalities in teaching methods. Art teachers introduced their projects or units at the onset of class sessions; reviewed, reintroduced, or clarified steps, procedures, technical details, and expectations as needed; and spent a great deal of their class room time advising, critiquing, counseling, and monitoring student work. Art teachers typically encountered both highly talented, self-directed students with high-level needs and, at the same time, students who were uninterested, distractive, and unproductive.

Gray and MacGregor identified teaching dynamics developed by art teachers and unique to art classrooms: *responsiveness* to variable student needs; *persistence* in providing individualized instruction and coaching in response to student requests for assistance; *engagement* with students throughout the session; and *alertness* to everything going on in the classroom. Finally, Gray and MacGregor found that art teachers spent a great deal of time planning

and preparing for instruction and that lessons were carefully presented, but that formal written lesson plans were largely absent in art classes. In their place were concise teacher-developed lesson aids.

Research on Art Teacher Thinking

With a few notable exceptions, there has been little inquiry about art teacher thinking, planning, or decision making. For that matter, there is a scarcity of any kind of research in typical art classrooms with the exception, during the last few years, of research promoting particular curriculum initiatives or teacher assessment and evaluation approaches and systems. The handful of studies of art teachers in public school classrooms that do exist are useful, however, for describing teachers' perceptions of their various school roles and of the their work conditions (May, 1989, 1994); their concerns about of preadolescent students (Stokrocki, 1988, 1990a, 1990b); and the political and institutional conditions necessary for art teachers to implement and sustain curriculum reform (McLaughlin & Thomas, 1985). Studies conducted in art classrooms by Anne Bullock and Lynn Galbraith (1992) and Mary Stokrocki (1990a) are particularly revealing.

Bullock and Galbraith (1992) identified four themes that characterize K-12 art teachers' concerns: (1) a sense of *dissonance* between what teachers want to do and what they can actually do in schools; (2) *frustration* with scheduling, overwhelming numbers of students, widely varying ability levels in the same classes, lack of time to teach the sort of art experiences that students should have, and frustration with external perceptions of what they should be doing; (3) a sense of *urgency and mission*, the realization, in the case of one art teacher that "a semester might be the only art a student gets their entire lifetime"; and (4) *compromise*, as each art teacher was willing and able to modify instruction and accommodate the realities of school life.

Stokrocki's (1990a) study describes art teachers' perceptions and reactions to students' mood swings and disruptive behaviors and to the oppressive and unreasonable institutional demands and contingencies of their jobs (large classes, lack of funding, inferior supplies, and lack of administrative support). She recommends that art teachers utilize more interactive instructional strategies (including cooperative curriculum planning with students) and greater involvement in school and community life, whereby supportive networks can be formed with administrators and parents.

When Lankford and Mims (1995) asked elementary art teachers what they perceived to be their greatest challenge, many teachers cited their struggles

with overwhelming numbers of students and diverse student populations, inadequate facilities and budgets, lack of time to develop quality art programs, and problems with student discipline and motivation. Lankford and Mims conclude that art teachers need to be better prepared for their professional work (teachers should be taught management techniques for setting priorities and allocating time) and better supported once they reach the classrooms (through advocacy efforts targeted to public school administrators and through research geared toward improving the conditions of teaching art). Wanda May (1994) argues that *university art educators who do not address the overwhelming complexities and contradictions of teaching K-12 perpetuate these conditions* and suggests that university educators engage in more participative work with public school art teachers.

Improving Art Teaching: A Word to Art Teachers and Reformers

Art teachers' thinking, planning, decision making, and response to the conditions of teaching are important but undervalued aspects of their work. Art teachers are told to do a better job, but little time or money is given for professional development and scant attention is paid to the factors contributing to art teacher stress and burnout. To be sure, art teachers, like doctors, lawyers, and other professionals, need to keep current. They need to be aware of research findings, divergent practices, and educational innovations if they are to renew their own professional knowledge and practice and to have a voice in ongoing debates about education. Currently only 10% of this nation's art teachers belong to the National Art Education Association (NAEA), and only about 20% of the membership attends NAEA annual conferences where teachers, researchers, and policy makers come together to share, discuss, and debate theories, practices, and innovations in teaching.

In the same vein, academics and education theorists espousing programs for reform need to get in touch with the realities of teaching art in today's schools. Some art education theorists and policy makers have never taught in the public schools; others have not stepped foot into a public school classroom in over 20 years. Recommendations for the improvement of art instruction should take into account the context in which art teaching occurs. *At the very least, academics and reformers should work more directly with public school art teachers than they presently do.*

The isolation of art teachers from one another and their lack of professional association with universities and professional organizations diminishes their

sense of efficacy and satisfaction. Renewal, re-enchantment, and re-enfranchisement with the profession is attainable when public school and university art educators work together on our common goals: making art a more meaningful part of the lives of children and working toward a more humane world.

— 3 —
The Primary Methods of Teaching

I hear and I forget. I see and I remember.
I do and I understand.
(Edwards and Mercer, p. 37)

Educators often use the terms *method* and *strategy* synonymously. For the purposes of this book an *instructional method* is defined as a comprehensive instructional approach that can be used to shape subject matter, design instructional materials and events, and guide student activities. An *instructional strategy* is smaller in scope, describing more detailed and specific instructional behaviors. Both methods and strategies involve planning, lesson preparation, interactions with students, management of materials, and evaluation. They are based on particular assumptions about learners and social systems which describes teacher and student roles. This chapter describes instructional methods, ranging from formal teacher-centered approaches to informal, interactive, student-centered approaches. The chapter following reviews popular teaching strategies.

Instructional Methods

Instructional methods describe the ways in which subject matter will be presented, examined, and acted upon in the classroom. Methods of instruction vary along several dimensions: degrees of activity on the part of teachers and learners, allocations of time for discussion and interaction, the nature of materials and instructional resources utilized, and degrees of autonomy and independence afforded to students.

The Lecture Method

Lectures are the most direct and formal of teaching methods. Lectures cover a large amount of material in a small amount of time. They are suitable for both large- and small-group instruction and are useful with both beginning and advanced learners. Teachers have control over content as well as the sequencing of information. Lectures are effective for explaining ideas dealing with abstractions that cannot be shown through concrete means. In every instance, the lecturer must have credibility with the audience.

Formal lectures involve one-way communication. The process is simple: Teachers lecture, students listen quietly. The most common type of formal lecture is *expository*, a body of knowledge is presented and discussed by the presenter. Each point is made, one by one, leading up to a conclusion. Expository lectures are the easiest type of lecture to present and prepare. A *problem-centered* lecture begins with the introduction of a problem; presents two or three potential solutions, considering the advantages or disadvantages of each; and typically ends with a solution. *Point of view* lectures present an argument, in which a principle or goal is stated and supporting data is outlined.

Teachers' formal lectures, with or without visual aids, invite minimal audience interaction. Asking questions of the lecturer and opportunities to interrupt are discouraged by teachers adhering to this format. Under these conditions there is little or no check to see if students comprehend material being presented. For these reasons, most educators advocating the lecture method recommend combining it with other methods.

Lecture-discussions are more interactive and student centered than formal lectures. In lecture-discussions teachers may ask questions and briefly discuss key points with students or assign knowledgeable students to present information to the class. In lecture-discussions students may also participate by asking questions, but the discussion and questioning are generally guided by the teacher.

Slide lectures or lectures given in conjunction with other instructional media (including computers, laser-discs, short videos, etc.) are potentially more appealing to the listeners (providing that the visual material is sufficiently interesting). The use of more sophisticated media requires specialized knowledge about the technologies associated with computers, other equipment, and software programs.

Effective lecturing is a difficult skill to acquire. The following recommendations may be helpful in planning lectures.

1. **Plan the presentation thoroughly, determining its focus and purpose, and outlining major and minor points to be made.** Make the focus and purpose of the lecture clear to students from the beginning, so that they know what to look for. Introduce lectures with a brief summary of key concepts to be covered in the lecture, and the relationship of those concepts to students' existing knowledge. Limit lectures to a few main concepts which are then explicated through examples. The end of a lecture should present a concise summary of the points covered.

2. **Present the lecture in a manner interesting to students.** Introduce the lecture with a challenging question, a puzzling situation, an anecdote or demonstration to gain student attention. Use audio, visual, or multi media to clarify concepts and to hold attention. Theatrics (voice modulation, gestures, dramatic movements, and props) are also necessary to hold attention and to alert students that a key point is about to be made. Develop selected concepts through examples drawn from experiences familiar to students. Although frequent examples should be given, anecdotes and jokes should be used with discretion because, when overused, they detract from the message.

3. **Use the lecture method in combination with other methods**. Lectures combined with discussions, question-and-answer sessions, and demonstrations make material more vivid and memorable. Plan for flexibility, and allow for student initiative and interaction with the lecture material.

4. **Provide immediate follow-up activities that engage students with the material covered in the lecture.** Students should be given opportunities to reflect upon and apply material presented in lectures, and lectures should be related to ongoing or new student inquiry or work.

5. **Know your topic.** Students perceive quickly the degree of knowledge a lecturer has about a subject. Expertise in a topic requires in-depth study, extensive preparation, and careful thought. The use of notes may be helpful when dealing with new information, but they should be used primarily as a reference, rather than a script to be read.

6. **Determine the practical needs for carrying out the lecture.** Pronunciation of unfamiliar words and names may require practice (and a phonetic guide in some cases). Vocabulary terms may require an explanation. Be prepared for requests for definitions. Rooms not adequately darkened diminishes the impact of slide lectures. If darkening shades are not available, consider another presentation mode (such as using books, prints, or postcard size reproductions). Know how to troubleshoot and work with sophisticated computer-driven instructional media.

Demonstrations

Demonstrations serve more effectively than lectures in clarifying abstract concepts, generalizations, and complex processes. In demonstrations, the instructor has to impart not only knowledge but skills. Normally the modeling of some sort of procedure is involved. The use of this method is based on the idea that seeing something being done enhances learning (Levine, 1989).

Like lectures, demonstrations vary in their degree of formality. Joel Levine (1989) identifies three distinct types of demonstrations: *Pure demonstrations* are presented with minimal commentary so that students can focus on skills and procedures without interruption. Pure demonstrations allow learners to observe an entire process performed in real time and may precede or follow other types of demonstration. In *demonstrations with commentary*, process, skills or techniques are performed with timely, concise explanations to facilitate student understanding of complex tasks or techniques. Verbal explanations reinforce and explicate complex processes that may otherwise go unnoticed. In *participative demonstrations,* students are given the opportunity to replicate or practice all or parts of the demonstration while the teacher presents the steps. Participative demonstrations are the least formal, most time-consuming, least efficient, and most unpredictable type of demonstration. Like other informal instructional methods, they may also be the most fun, engaging, and informative for students.

Well-planned demonstrations are challenging, flexible, and adaptable to different situations (Charles, West, Servey, & Burnside, 1978) Demonstrations can be repeated. Like lectures, a demonstration is more likely to be of interest to students if they have a general idea of what to look for as it proceeds (Levine, 1989). Teachers need to be cognizant of students' needs during demonstrations. If care is not taken, learners may not be able to see or hear demonstrations in progress. Levine also suggests that teachers ask and encourage questions during demonstrations, to stimulate further interest and to assess the degree to which students understand the processes being modelled.

Effective demonstrations require practice and skill on the part of the presenter. When things go wrong, the instructor may lose credibility. Like lectures, demonstrations should be followed up with student opportunities to interpret, apply, and practice concepts and skills demonstrated. Bruce Joyce and Marsha Weil (1980) have looked extensively at demonstration and training models in the classrooms and have summarized this method into five essential phases:

1. *Clarification.* The instructor clearly specifies the objectives of the activity. A good demonstration begins with an overview of what will be shown, often prefaced with an explanation of what students should be looking for.

2. *Rationale.* Once the goal and component tasks have been explained, a *theoretical explanation*, or rationale follows so that the learner has a better understanding of why particular concepts and skills are being taught.

3. *Modeling.* The demonstration is done in a simplified way so as to accentuate the essential elements and minimize the number of steps students must remember. Demonstrations are more effective when verbalization accompanies them. Each step is performed, stressing its context in sequence, so that the skill is seen as a whole rather than a set of isolated tasks. After skills are demonstrated, attention is drawn to key points relating to those skills. Some instructors demonstrate slowly, explaining each step as it is shown, then they demonstrate it again at normal speed. As students become adept at reenacting the process, teachers may add nuances and demonstrate more complex processes.

4. *Practice with guidance.* After processes have been modeled, students *practice* elements of the task in *simulation exercises*. The instructor must provide specific visual and oral *feedback* and guidance during this phase. Some skills will be mastered quickly, others more slowly. Task components must be mastered before students are asked to put them together into complex operations. This phase of the demonstration method broadens the instructional focus from modeling or showing to guiding and responding. The expert or more competent peer guides the novice, or *apprentice*, through both discovery and guidance and toward competence and mastery.

5. *Transfer and internalization.* In the final phase, activity is shifted to the performance of the actual goals as they might be pursued in realistic situations. As this *transfer to actual goals* is undertaken, students gradually provide their own feedback and proficiency improves.

The demonstration method of teaching (also called the apprenticeship, the training, or the coaching method) is widely used in teaching simple and complex concepts, skills, and processes involved in art making. It is equally appropriate in teaching inquiry processes involved in the study of art history, criticism, and aesthetic theory.

Instructional Games

Games are task-oriented interactive activities that are relatively short in duration, slightly competitive, and designed in such a way as to simulate recreation. Instructional games are a versatile indirect instructional method that can be used to engage students in simulations of problems, events, and inquiry processes. Instructional games can be played by any number of students, can be simple or complex, can involve the use of minimal or elaborate instructional media, including visuals, audios, and computers. Games and simulations may be followed up with reflective writing and exciting discussions or debates. Al Hurwitz and Stanley Madeja (1976) tout the benefits of using games as an instructional method, claiming that games make use of one of the oldest formulas for effective instruction, to teach and delight. The process itself of playing games is the key to their success as content delivery systems. Hurwitz and Madeja (1976) provide a useful summary of the nature of games with attention to educational applications:

1. **Game playing is purposeful.** Game playing should be directed toward the pursuit of a goal or object, the completion of some task, the development of new ideas, or the performance of some skill.

2. **The process of playing games must be rule-governed.** Games should have a discernible goal, a beginning, procedures to follow, and a clearly designed ending. When objectives are reached, the game should feel "finished."

3. **Competition is internalized as "challenges to meet" rather than "opponents to beat."** Games should be developed in such a way that they become competitive only insofar as variable solutions to challenges are compared, performances are evaluated, or answers are explained and examined. Students should feel comfortable engaging in risk-free investigation and conjecture. Only in limited situations does one win or lose.

4. **Games should be entertaining.** Conceptually based games (built around concepts and generalizations) and games designed to sharpen perceptions or enhance the aesthetic response should be fun for students. For the purposes of this book, it is assumed that the pleasurable aspects of game playing will provide some positive attitudinal changes toward art in general.

Instructional games are highly regarded among art educators as a method of involving students in the study of art, and a great variety of visual and conceptual art games have been developed over the years. Art games deal with visual, conceptual, and aesthetic dimensions of art and allow teachers to tap

into students' perceptual, analytical, and creative abilities. Some art games cue students to the visual attributes of artworks, engaging students in identification, classification, comparison, matching and sorting activities. Newer generations of art games involve not only perception and analysis activities but also sophisticated inquiry activities designed to engage students in historical and aesthetic inquiry, synthesis and evaluation, critical reasoning, philosophical dialoguing, and metacognition. Some games also utilize speculative and analytical writing about art and artists.

The expanding availability of a broad range of game-like learning activities makes the use of art games an enticing instructional method. Chapman (1978) suggests the use of game-like formats in evaluating student learning. According to Chapman, games can easily be combined with record sheets or journals in which students record, justify, and compare their ideas.

Discussion Methods

Talking *with* students (discussion), rather than talking *to* students (lecturing), is the basis of the discussion method of instruction. Discussions take many forms — from the brief exchange to clarify facts during a lecture or demonstration to large- panel discussions to express a variety of opinions (Levine, 1989). Discussions are more interactive and student oriented than lectures and demonstrations. Educators warn that there is little point in holding class discussions in which students are merely asked to pull facts out of a textbook. Rather discussions should be opportunities for students to share ideas, creatively apply the information they have been studying, and assist one other. Discussions are especially useful in solving problems, exploring issues, and making group decisions cooperatively (Charles et al., 1978).

Like poorly planned lecturing and demonstration, discussions with insufficient planning are problematic. Failure to find and maintain a focal point for discussion confuses rather than clarifies. Too many opposing viewpoints sidetrack discussions and disorient learners. In addition, teachers must ensure that all students feel secure in expressing personal views and that discussions are not dominated by a few students. A trusting classroom environment must be established from the opening day of class, when crucial first impressions are being made (Levine, 1989). Finally, discussions require advance preparation, both by the instructor and by the students. The best way to ensure thoughtful participation is to make sure that students know what they are discussing.

Discussions can take place in a variety ways: debates, case studies, whole class, and experiential small groups. Each of these formats offer interesting

opportunities for students to formulate and share ideas. Art teachers may require students (independently or collaboratively) to examine, read about, and write about artists, artworks, and issues before discussion ensues.

The most formal type of discussion is the *debate*, which follows rigid rules. In classroom debates, a problem is given, varying or opposing perspectives are pursued by students (working alone or on teams), arguments and counter arguments are presented and examined, and a reiteration and conclusion are offered. Students may be assigned roles to enact during debates to ensure that a wide range of views are addressed. Debates may be presented in game-like formats, where the competitive edge may be softened by novelty, challenge, and a moderately recreational undertone.

Case studies involve the critical examination of subject material, posed in the form of a real or simulated problem. Problems may be presented orally or in written narratives, posed in videotapes, or role-played. Case studies are often linked with debates as a method for exploring contested concepts, principles, and values. Peter Dawson (1984) identifies several kinds of case studies:

- *Critical incident cases* are blow-by-blow accounts of events leading up to a problem situation. Learners are asked what information is required before a solution can be negotiated and how that information might be obtained.

- *Next stage cases* are presented as facts leading up to a problem. Students are asked what is likely to happen next.

- *Live cases* are derived from real, often current, events appearing in the broadcast media. Students are asked to predict what will happen and check their predictions as the real events unfold.

- *Major issue cases* are comprised of a vast array of information, facts, opinions, and actions. Students are asked to identify the problem and to consider possible solutions.

Role-playing often used in combination with discussion, combines elements of demonstration and case-study methods. Students study a situation and act out an incident for themselves (rather than reading about it or watching it on a videotape). Discussion follows. The same or other students may reenact the same or similar situations, followed by further discussion. Closure is brought by reviewing discussion points and issues and sometimes consensus is sought.

In *experiential small groups* the atmosphere is relaxed and informal. There is a free flow of question and debate. Although the setting is relaxed, the dis-

cussion is planned and organized by the instructor. Small group discussions should have a definite beginning, middle, and end. After a brief introduction by the discussion leader, discussants pursue points of interest and issues of concern. Whenever the discussion appears to be running out of steam or losing direction it can be refueled by posing challenging questions. There should be a clear objective throughout the discussion, and it should end with a conclusion. This is best accomplished by summarizing the main points made during the discussion.

The advantages of discussion methods are that they (a) at least in theory, permit everyone to participate in the learning situation; (b) pool student knowledge, abilities, and experiences in the realization of a common goal; (c) are highly stimulating and challenging; and (d) foster group work, a goal valued in formal education. On the debit side, discussions (a) can degenerate into aimless debates unless properly organized and managed by discussion leaders (who may be students); (b) limit the number of people that can participate at one time; (c) are time consuming; and (d) can be dominated by autocratic teachers or highly verbal or aggressive students. Good preparation and clear focus are two keys to effective discussions. Rules must be maintained to ensure fair participation. Careful briefing and debriefing are also essential. Advance preparation of students must precede discussions, and some degree of closure, however provisional, must be provided in discussion sessions.

Methods for Art Education

Dialogue

Issues in the contemporary art world, including changing traditions and modes of inquiry in art history, criticism, and aesthetics provide rich, timely, and provocative topics for possible classroom discussion, study, and debate. Art teachers wanting to incorporate some discussion of contemporary issues in the art world can find articles in numerous art journals (*New Art Examiner, ARTNews, Art Forum, American Craft, Interview,* to name a few) as well as in widely read news periodicals such as *Time Magazine* and *Newsweek,* newspaper and magazine clippings, and local and national nightly news broadcasts on television and radio. Art educators seeking an excellent compilation of case studies in the art world should consult *Puzzles About Art: An Aesthetics Casebook* (Battin, Fisher, Moore, & Silvers, 1989). Students may also be asked to listen for, collect, and bring to the classroom arts topics under public debate. Art educators have developed varying strategies for engaging students in discussions about art, based on topics, issues, and debates occurring in the larger culture or focusing on artworks made in class.

Marilyn Stewart (1991a) has developed a series of simulations, inquiry games, and discussion activities centered around art history, art criticism, and issues in aesthetics. Her strategies include the use of role-playing, inquiry games, and confrontational dialogues. For example, in an activity Stewart calls "Great Debates," students role-play and debate particular beliefs about the nature and function of art in a hypothetical situation but one derived from an actual debate occurring in the community or the culture at large. In one debate, students are given different belief statements (summaries of particular beliefs about art written on cards) that they must argue and defend as they enter a debate about a *found object* placed on a pedestal by an artist and being considered for placement in a museum.

Sally Hagaman (1990) favors a more conversational, less adversarial mode of classroom dialogue. In Hagaman's approach students read and discuss stories or short episodes written for children about the art and art-making practices of diverse cultural groups. Questions that emerge in student discussions are written on the board by the teacher to identify central ideas and concerns expressed by students and to focus further discussion and clarification of aesthetic concepts and issues. Particular issues are selected for focused inquiry and subsequent discussion by students. Hagaman's approach fosters "a class climate wherein each child feels comfortable to express an opinion or observation, with an end goal of largely child-child rather than teacher-child discussion" (1990a, pp. 24 & 33). For Hagaman the development of critical thinking skills occurs through dialoguing, discussions in the classrooms that build around the notion of a "community of inquiry."

Whether one utilizes Stewart's Socratic style or Hagaman's more conciliatory style, both approaches teach students similar strategies for dealing with questions and issues in the art world: (a) how to support one's assertions through the development of sound reasons — based on criteria that can be explicitly verbalized and observed by others; (b) how to adapt, modify, and self-correct one's ideas — based on a willingness to listen, reconsider, and recompose conceptions; (c) how to make judgments as they occur in specific, real settings — the importance of context (Hagaman, 1990a, p. 33); and (d) how to reach consensus through compromise and respect for a diversity of opinion — making decisions while providing opportunities for dissenting views to be expressed.

Peer Groups and the Critique

One of the advantages of the small discussion group is the intimacy it provides. Students reluctant to offer their opinions and insights in large class

discussions may feel comfortable in expressing their ideas in small groups. Formal and informal models of *peer conferences and peer interviews* are gaining favor in many schools as an assessment strategy. In small peer-groups, students offer advice, analyze each other's work, ask questions about choices made, and react to each other's ideas and intentions (Berger, 1991). Rieneke Zessoules and Howard Gardner (1991) note that peer response sessions and interviews place students in the role of active participants in assessment. Students may participate in lengthy small-group or one-on-one discussions about their artworks, posing challenging questions for one another and engaging in thoughtful judgments about processes and results. Grant Wiggins (1993) observes that some forms of peer review place a high premium of the contributions of classmates. He describes some assessment practices in which student work must be evaluated and "initialed" by another student before it is handed in, and in which students get a grade both for their own work, and for the paper on which they signed off. This policy makes it clear that the student is responsible for critiquing the work of others.

Inquiry Training

Inquiry training goes by many names and has a range of adaptations: the scientific method, inductive reasoning, critical thinking, metacognitive instruction, discovery learning, and open education. What unites these approaches is an interest in teaching thinking skills through direct encounters with materials and/or problems. The goal of inquiry is developing sophisticated explanations and strategies for solving problems and learning to consider the opinions and explanations of others.

John Bruer (1994) has written extensively about inquiry training as a method of teaching. He refers to self-discovered learning as the most uniquely personal learning humans are capable of. The process of learning through inquiry increases self-confidence and shifts motivation for learning from extrinsic rewards to internal ones. For Bruer (1994), inquiry training should involve activities centered around *ill-defined problems.* An ill-defined problem is one for which there is no ready-made, best explanation or representation and no standard method of solution (Bruer, 1994). Richard Suchman (an early proponent of inquiry training in science education) believes that children should be taught that genuine inquiry is ambiguous, that all knowledge is tentative, and that there are no permanent answers (cited in Joyce & Weil, 1980).

Inquiry training is one of the most versatile instructional methods in education. It can be used at all grade levels and can be combined with lectures and demonstrations, discussions or debates, large-class instruction or small co-

operative learning groups, group or individual projects, and games and simulations. Inquiry training may be teacher-directed or incorporated into more student-centered self-directed environments (Joyce & Weil, 1980).

The teacher's role in inquiry training varies. It may include introducing problems or challenging puzzles to solve, providing background information or helping students focus on a topic of inquiry, providing sufficient materials, asking fruitful questions, clarifying thought, and examining answers with students. The student's role in inquiry training is to gather and observe data, organize them, formulate hypotheses, test hypotheses against existing evidence, and eventually, select problems to pursue independently (Joyce & Weil, 1980). Contemporary applications of inquiry training include classroom learning centers, laboratories, science fairs, the critical thinking movement, creative writing, Socratic dialogue, and reciprocal teaching. Its strength lies in teaching students the processes of thinking, as well as how to ask their own questions, formulate hypotheses, observe, and make use of problem-solving methods. Inquiry training helps students learn how to find and apply information on their own and how to think for themselves without having to turn to authorities for answers (Bruer, 1994).

Discovery Learning and Inquiry Training in Art Education

The following brief descriptions of instructional approaches in art education highlight how the creation and study of art can foster sophisticated inquiry processes and higher order reasoning skills.

The creation of art. Marilyn Zurmuehlen calls studio art the "conversion from unreflective to reflective thought" (1990, p. 5). Zurmuehlen, agreeing with Suzanne Langer, believes that symbol making is rooted in the mind's capacity to synthesize, delay and modify one's reactions to the world, and construct order from the chaos of direct experience. Art classes, for Zurmuehlen, are sites where students can be originators: intending, acting, realizing, re-intending, combining critical reflection and action. These are not the activities of an unwieldy mind, as some would have it; rather they are the result of purposeful, critical inquiry put into deliberative action, or *praxis,* as Zurmuehlen would say. The artifact itself is tangible evidence of the critical thought that went into its production — it is the construction, the creation, of personal knowledge.

Candace Stout (1992) links art making to the widely popular *critical thinking movement.* Teaching for critical thinking, for the art teacher, means cre-

ating an environment in which students construct their own knowledge and take responsibility for their own learning (Stout, 1992). Students become adept in conceptualizing, analyzing, synthesizing, and evaluating ideas and make meaningful applications of knowledge. Critical thinking is arguably exactly what students do when they create and assess their own art or when they participate in critiques of each other's works.

The artist's journal. Professional artists' journals, are an excellent example of critical, creative, and divergent thinking. Stout (1992) advocates "journalling" as a classroom strategy to promote cognitive growth and to help students make sense of their learning. Unlike traditional "school writing," journal writing is explorative, personal, and self-directive. Rules may be broken because the focus is on meaning (not spelling or grammar) and the writing style is informal, expressive, conversational, or, as Stout observes, *dialogical.* Just as teachers provide models in other processes, Stout believes that teachers should provide models of good writing, demonstrating the manner in which journal writing reflects the teacher's own thinking processes. Such models would include statements as well as inquiries.

Artists' journals as self-assessment. Rieneke Zessoules and Howard Gardner (1991) recommend having students keep daily journals in which they track their daily progress, describe what they did in class, and note choices and decisions made. Entries would include dates, observations, ideas, judgments, and reflections. In such a journal, students might also write about a series of their works over time, their progress on a particularly difficult or lengthy work, and their own artistic growth over time, following and defining the ups and downs of their work (Zessoules & Gardner, 1991). Students may also be encouraged to attach notes (reflections) to the backs of their works, using post-it paper. Dennie Wolf (1988) recommends, that art teachers require students to document the "biography" of their artworks, from the inception of the idea to early drafts and peer criticism to the final versions. Grant Wiggins (1993) recommends that teachers assess and evaluate student journals as part of their grade. Elaborations on this approach are also found in the descriptions of students' *research workbooks* required in the International Baccalaureate Program (Anderson, 1994).

Art criticism as interpretation. Art criticism involves the intricately connected processes of description, interpretation, and evaluation (Risatti, in Clark, Day, & Greer, 1987). These processes, in turn, rely on evidence gathered from the intrinsic qualities of art (formal, technical, and expressive properties) and external points of reference (contexts, conventions of interpretation, and current standards of value). Howard Risatti observes that critical

evaluations are statements about qualities and ideas (or values) derived from the larger social and cultural context. In Terry Barrett's view, interpretative statements are persuasive arguments. Critics use logical reasoning (premises and conclusions); utilize evidence to support assertions of meaning; and employ a lively, colorful language to engage others in the critic's point of view (Barrett, 1991, 1992).

In an attempt to engage young students in art criticism art teachers run the risk of focusing student inquiries too heavily on the identification of design elements, ("Who can name the colors in this painting?" "Describe the shapes you see," etc.). To find out how young students might describe the pervasive emotional and aesthetic qualities in artworks and whether they could convey their descriptions adequately to others, I tried an experiment with Valerie Piacenza, an art teacher at Sunnyview Elementary School in Carpenterville, Illinois. We lined up about 10 Shorewood prints (all having different themes, styles, and expressive qualities) at the front of a class of first graders, and asked students to play a little game we called "In the Mood." One student was asked to study all of the prints for a few moments while the rest of the class covered their eyes. The task given to the student was to describe the feeling/tone of a print selected by that student, using only words that sug-gested emotions he or she felt the painting expressed (cheerful, happy, sad, scared, etc.) or aesthetic qualities present in the print (energetic, moving, calm, peaceful, chaotic, etc.). When the student studying the prints was ready, the rest of the class was invited to examine the prints and guess which print the student proceeded to describe. This game was played several times in the class session, with different students assuming the task of description.

Role-playing the critic. Valerie and I, impressed with the success of "In the Mood," moved on to third graders. We divided them into teams of three and gave each team a print to interpret. Students were asked to begin with their personal interpretation of the painting's meaning, to follow up by seeking evidence for their interpretations, and, finally, to elect a spokesperson who would then tell the entire class "what the painting was about." Surprisingly, some of the teams could not agree on the meanings of paintings and would not relent in their convictions, regardless of others' persuasive arguments. They decided to present diverging views to their classmates, each arguing for and supporting their own interpretation — third graders! When teachers take advantage of deviations from their mental scripts of what they think should happen in the classroom, wonderful things can emerge.

Art criticism is about uncovering and conveying the possible meanings of artworks to others, using as evidence, observations about the work itself and

information about the artist and the context in which the art was made. In an attempt to focus students on all potential sources of evidence, I have asked students of various ages (after studying the life, letters, and works of Vincent van Gogh) to write a "letter to Theo," in the manner of Vincent, about a selected work painted by van Gogh. Students write amazing letters, pouring out their hearts about the nature and purpose of particular works; providing explanations, as Vincent often did, for particular subject matter choices or colors used; talking about (again, as Vincent often did) what it is like to be an artist; and even asking Theo for money for paint and brushes.

If what art students can do in the classroom come close to Risatti's and Barrett's descriptions of art criticism, art critical inquiry is, indeed, high-powered thinking — descriptive and interpretive analyses and syntheses of information derived from divergent sources, putting into action complex valuational processes, and involving the articulate and expressive use of words. Art critical inquiry must be modeled by teachers and practiced *by students* for these things to occur.

Doing art history. According to Virginia Fitzpatrick, art historians analyze, interpret, synthesize, and convey information about art. They authenticate the artists of particular objects, trace provenances, and reveal relationships among artworks (Fitzpatrick, 1992). Mary Erickson defines art historical inquiry as establishing facts, interpreting meaning, and accounting for change (Addiss & Erickson, 1993). According to Erickson (1994) and Fitzpatrick (1992), these procedures require skills of detailed observation and description, making comparisons, drawing inferences from available evidence, interpreting symbols, looking for additional information to confirm hypotheses, proposing explanations, supporting conclusions, and asking questions. Art historical inquiry, for both Fitzpatrick and Erickson, involves learning not only factual information but perceptual and cognitive skills and the development of values that support attitudes and dispositions conducive for learning.

Two art historical inquiry activities, developed by Eldon Katter (1988) and Mary Erickson (1983) model this approach: *Art in Time* and *Ask Picasso*. *Art in Time* involves the use of over time postcard reproductions of one artist's work (in this case, the work of Pablo Picasso). The students, working collaboratively in small groups, are asked to develop a chronology of that artist's work based on physical and thematic cues evident in the works. Students check their guesses against the facts (the actual dates of production) and discuss why they made correct and incorrect conclusions. *Ask Picasso* follows *Art in Time*. In *Ask Picasso*, students (again working cooperatively in small groups) discuss and construct questions they would ask Picasso (any

artist may be substituted here) if he were still alive. They then construct a research plan describing how they would find answers to their questions. The plan would include locating and utilizing both primary and secondary sources of information and documents.

In both these activities, students work collaboratively and share their observations, conclusions, and speculations in whole class discussions. To do so requires looking, talking, studying, reading, and writing. In this approach to art history instruction, students *do* art history rather than *hear* art history.

Aesthetic inquiry: Questions, problems, and problematic questions. Like Erickson, Louis Lankford (1992) observes that the goal of inquiry is not merely the development of a knowledge base but the confidence and determination to rely on one's own abilities. Lankford believes that inquiry methods are particularly well suited to aesthetics, "since questions in aesthetics seldom have absolute answers." (1992, p. 50). Lankford's recommendations center around activities in which students discuss varying conceptions of art raised in problems or issues from the art world. (Lankford, for example, uses the case of Ruby, the painting elephant, to raise questions about art in discussions with students). Karen Hamblen (1986) takes this approach in a slightly different direction, suggesting that students explore *contested art concepts* by examining and discussing personal objects that they value or find aesthetically pleasing. The purpose of this kind of metacritical inquiry would be some sort of student consensus about the dimensions of art objects and the criteria employed in evaluating art. Lankford believes that discussions about the nature and functions of art need not reach consensus, an anticipated conclusion, or a "theoretical end-in-view"; rather "thinking deeply about art" may be the primary goal. In Lankford's view, the desired educational outcomes are associated as much with process as product. The processes valued, Lankford continues, "are characterized by participation, questioning, analysis, investigation, discovery, testing ideas through their applications, and the tolerance, open-mindedness, and acceptance of alternatives" (1992, p. 50).

The Project Method

Projects are planned undertakings that *students carry out*. Independent projects allow for the integration of learning as it occurs in natural situations and relationships, rather than in the logically organized patterns typical of most school subject matter (Levine, 1989). The strength of the project method lies in the way it helps students organize and apply information, show responsibility, follow through, and make sense of what they have learned (Charles et

al., 1978). The project method encourages free choice and fosters the development of both interpersonal skills and intra personal skills, as self-concept rises with competence (Charles et al., 1978). Attitudes, values, self fulfillment — few kinds of instruction provide so many positive possibilities as the project method. Next to role playing and simulations, no method of teaching brings about more intensive student involvement than does the project method. This involvement is not forced or coerced. It puts students in charge of their own learning: They get to plan and organize their work. Students may work in small groups or individually. In either case, they get to do the fun part, the legwork, the rummaging around, and in the end they have a tangible product to show (Charles et al., 1978). A particular strength of the project method is its breadth of effect.

Students in art classes can plan and execute independent projects of all sorts in addition to making works of art: creative writing, construction of models, research, mapping, measuring, and so forth. A project may be a creatively developed object (a model), a document (a research report), a narrative (photo essay), or a composition (a literary work or a journal). A project may also focus on process rather than product. For example, independent research projects may be undertaken that focus on specific analytical procedures and inquiry skills rather than end products. Process portfolios, collections of investigations, and a sampling of exercises and techniques may serve as tangible evidence of project work.

Art projects comprise, perhaps, the primary "stuff" of art education in the public schools. But the aims of the project method, just described, may or may not be achieved in typical art classrooms. George Szekely (1988) studied art teachers' (grades 3 through 12) lesson plans, decision making, and classroom interactions for 3 years and found that in most cases, the art teacher pre-selects the materials, supplies, spaces, themes, and intended outcomes of student work. Criticisms, evaluations, and directions for executing and refining artworks produced in the classrooms emanate almost exclusively from teachers, and students have little understanding of how art teachers come to decide on particular lessons or why prescribed experiences are valuable to pursue. Nor can students say what they have learned from their work or how they would apply their experiences to new works. Most importantly, for Szekely, students have little or no warning about what they will be doing before entering the art room, and they spend little time preparing for work, physically, mentally, or conceptually. They simply follow teachers' instructions given at the beginning of lessons. In other words, all the decisions and creative choices have been mapped out by the art teachers.

Szekely argues that students should be involved from the beginning in planning their artworks. This includes selecting their own "problems" to pursue, just as artists set problems to solve. For Szekely (1988), a successful art lesson is one that provides students with an opportunity to invent, to discover structures and principles, to generate their own ideas and act upon them after their schooling is over, and to understand art *as it is understood in the contemporary art world.*

Independent study is a variation of the project method. Independent study and individual projects are sometimes more open-ended than traditional projects or other instructional methods. Independent study and projects are based on the idea that students do not always have to learn from direct instruction or from group discussions. Sometimes it is appropriate for students to learn by themselves, under proper supervision. Independent study sometimes involves learners being given specific assignments. More often students select their own topics to pursue. In either case study is prefaced by clear objectives to be achieved, and learners need to know how they will be assessed. Objectives and evaluation criteria may be given by teacher or student or arrived at collaboratively. Some students respond poorly to independent study work, preferring the structure and routine of other methods.

Instructional Planning: From Teaching to Studenting

Expository (didactic) teaching is intended to make information as clear and understandable as possible. To ensure understanding, some teachers play a dominant role in the dissemination of information. Lectures and demonstrations are the most commonly used forms of expository teaching. For material to be clear and understandable, however, students must grasp (explain, put into their own words) concepts, generalization, and the processes being taught. In indirect (or heuristic) teaching, teachers encourage students to make sense of phenomena for themselves. Inquiry training, discovery learning, and the project method are based on the conviction that learning best occurs when students recreate the knowledge the scholar already has by doing the work themselves, rather than reading the textbook, memorizing the teacher's recitation (lecture) of textbook knowledge, or imitating in a lock-step manner another's performance of a process. The ways students think, judge, ask questions, and formulate, apply, and modify information are central to instructional planning.

The idea of spending an entire class session talking about art with children — inquiring about its form and structure, meaning, context, embedded symbolism, intentionality, or sometimes contradictory nature — is problematic for many art teachers.

Efforts to expand instructional programs along these lines are met with resistance because of art teachers' attitudes and expectations for what learning about art really means; lack of preparation in history, criticism, and aesthetic inquiry; and for some, their lack of skill and knowledge about viable methods for engaging young minds in inquiry about art. Successful efforts to incorporate student dialogue and inquiry about the contextual, symbolic, and aesthetic dimensions of art into the curriculum rely on substantial knowledge about art, the use of interesting, engaging instructional approaches, and competence in a variety of methods. This may include the preparation and delivery of effective lectures, skillful leadership of discussions, and cogent demonstrations of thinking processes. Preparing for lectures is extraordinarily time consuming, and art teachers are rarely given adequate planning time for such work. Moreover, preservice programs at colleges and universities prepare art teachers only for demonstrating studio media and processes.

Classroom discussions are inefficient and unpredictable as a content delivery system, and student gains in knowledge as a result of provocative, engaging discussions are difficult to document. But the growing popularity of inquiry-centered teaching methods and the accompanying authentic assessment movement suggest a dramatically different conception of teaching than the transmission or delivery of curriculum content. In such a framework, teachers become, in effect, students of their own classrooms, learning in concert with their students about the nature and value of art — and, in the process, learning how to be better teachers.

— 4 —
Instructional Strategies

*Competence in teaching stems from the capacity
to reach out to different children and to create a rich
and multidimensional environment for them.
(Joyce & Weil, 1980, p. xxiii)*

An *instructional strategy* is a specific instructional technique designed to foster particular learning outcomes or dispositions. This chapter describes several instructional strategies including advance organizers, questioning strategies, cooperative learning, Socratic dialogue, and synectics.

Advance Organizer

Advance organizers are summaries, concepts, and principles taught in advance of the material to be learned and written at a higher level of abstractness, generality, and inclusiveness than subsequent material (Alexander, Frankiewicz, & Williams, 1979; Platten, 1991). Students learn more when teachers structure the material by beginning with overviews that call attention to main ideas and important concepts (Brophy, 1983a; West, Farmer, & Wolff, 1991).

The construction of advance organizers must take into consideration the nature of the learning material, the age of the students, and the degree of their familiarity with the new content to be learned (Joyce & Weil, 1980). Meaningful learning — the ability to transform and apply new information — is intellectually linked to earlier learning. New ideas or material can be usefully learned and retained only to the extent that they can be related or accommodated to already available concepts and propositions. Ausubel called these already learned concepts "ideational anchors" (cited in Joyce & Weil, 1980). Jerome Bruner called them "cognitive structures" (1960, 1971), and later referred to them as "mental scaffolds" (1985) to convey the notion that the structures themselves are temporary. As students become comfortable with

basic concepts and principles, more complex ideas may be presented. Students "fit" new information into their present conceptions. The teacher's role is to promote what Ausubel calls "active reception learning" by gradually increasing the complexity of concepts and propositions and by continually adding new and different concepts to previously learned material.

Questioning Strategies

Research indicates that students learn more in classrooms where questioning is frequent (Good & Brophy, 1978). According to Thomas Good and Jere Brophy (1978), this may be because a high frequency of questioning indicates that the class spends most of its time on learning activities and that the teachers are supplementing presentations, demonstrations, and practice activities with opportunities for students to express themselves orally. Carmen and Nolan Armstrong (1977) describe questioning as a student-centered teaching strategy and suggest its use to involve students in higher types of art learning (discrimination, conceptualization, and generalization). Karen Hamblen (1984) also shows how questioning strategies can foster student involvement and the development of complex levels of thinking.

Several factors have been identified that link effective questioning techniques to both student mastery of material and the overall *quality* of the educational environment, including affective aspects and classroom climate. These factors are summarized in the following paragraphs.

1. *Clarity*: Clear questions are brief and highly focused; they describe or cue students to specific points of inquiry (Good & Brophy, 1978). Ambiguous, lengthy, or compound questions confuse and frustrate students and lead to random guessing. Questions should be phrased in simple language and adapted to the level of the class. This does not mean that teachers should not use new or big words. In fact, teachers may model sophisticated verbal communication abilities as long as they immediately clarify words and help students make these words their own (Good & Brophy, 1978).

2. *Purposefulness*: Good questions are both related to the instructional material to be learned and thought provoking (Good & Brophy, 1978). *Fact* or *informational* questions are often needed to see if students understand information basic to the discussion and help them focus on specific topics (Good & Brophy, 1978). Informational questions in art facilitate discrimination, requiring students to observe and identify attributes or qualities of phenomena and leading them toward the development of selected

concepts (Armstrong & Armstrong, 1977). *Probing* questions help students clarify their ideas and apply them to relevant situations. Probing questions may require students to apply previously learned material, analyze information gathered, or synthesize selected observations into generalizations (Armstrong & Armstrong, 1977).

Questions should be asked in carefully planned sequences. When they are mostly asked "off the cuff" classroom discussion tends to be irrelevant to the specific goals of the lesson and confusing to students (Good & Brophy, 1978). However, interesting and beneficial sidetracks should be pursued when they appear promising (Good & Brophy, 1978; Wolf, 1987).

3. *Selection of response modes:* Rosenshine and Stevens (1986) provide a useful summary of research on response modes and how effective teachers direct participation. Questioning and discussion may follow several formats: (a) *random* or *ordered turns*; (b) individual *volunteers* may be solicited; (c) *call-outs* may be accepted; and (d) *choral* or group responding may be effective in certain situations. *Ordered turns* are effective in smaller groups. They eliminate hand-waving and provide all students with opportunities to participate. In whole class instruction, it is more efficient to select certain students to respond to questions. Student *call-outs* are found to be negatively related to achievement gain among higher ability students but positively linked to gains for lower achieving students, suggesting that this technique may be most useful with students who are alienated or fearful of responding. Group *choral responding* is useful for all students during guided practice with new and more difficult material. The game-like nature of this activity makes it less threatening to younger or timid students.

Questions addressed to the whole class, followed by the selection of a wide variety of individual students for responses, is viewed as one of the most effective strategies for involving students in discussions. Teachers should encourage students to respond to one another and should describe how classmates' ideas fit together, especially when topics call for more than one right answer. Questions not only should occur between teacher and student but should flow *between students* (Wolf, 1987).

4. *Procedures:* The most recommended pattern for using questioning to stimulate class discussion is to (a) ask the question, (b) delay a few moments (3-5 seconds or longer), (c) call on an individual student to answer, and (d) *then wait again for that student's response* (Good & Brophy, 1978). Be sure to include the slower student (Wlodkowski, 1984). *Post-question wait time* should vary with the complexity of the questions (Brophy, 1986). Most importantly, teachers should respond thoughtfully

to all students' ideas, paraphrasing their statements and following up with probing or clarification questions.

5. *Teacher response and feedback*: Feedback motivates further interest in the topic, but more importantly, students need to know how they are doing. Teachers should respond to all student answers with specific feedback: affirming, probing, and paraphrasing students' contributions to the discussion. Research consistently reveals that teachers who provide regular and extensive feedback elicit higher achievement (Good & Brophy, 1978).

If a student answers correctly, a brief affirmation from the teacher is critical. It is important that correct responses be acknowledged as such, because even if the respondent knows the answer to be correct, other students may not. Phrases like "That's good" or" Excellent" should be used sparingly. They set the teacher up as judge and jury and lead students to search for and offer what they think will please the teacher, rather than for depth of understanding and provocative insights. Instead, acknowledgments and affirmations should serve as opportunities for further consideration or as transitions to related material: "You're saying that ... That must mean ..." (new question). A related question should follow quickly to maintain the momentum of the discussion.

If a student does not respond correctly or does not know the answer to the question, the teacher should rephrase the question, providing more information, rather than redirecting the same question to another student. Hints, prompts, or alternative questions are more useful when individual contacts remain brief (30 seconds or less) so that attention from other class members is not lost. Sometimes it becomes necessary for teachers to provide moderate amounts of *process feedback*, reexplaining steps or thoughts used to arrive at a satisfactory conclusion. Such activity both helps students still learning the material and affirms the internal responses of students who have mastered the material.

Sometimes student responses should be reinforced by teachers *paraphrasing* what the students say. This reinforces not only the material under study but also students' confidence in their own abilities to set forth their ideas.

Finally, it is important to keep in mind that there may be many situations involving critical or aesthetic inquiry in which there is no "correct" response (Lankford, 1995, personal communication). Students may be trying out their ideas and speculations for the first time *publicly* about relatively new topics. Teachers need to respond to all students with specific, useful feedback, even when student responses do not necessarily coincide with teacher's "questioning plans" or mental scripts of how the discussion should be going.

6. *Habits to break.* Research also indicates that unproductive question-asking frequently occurs habits in classrooms. Unproductive questioning strategies include *choice* and *yes-no questions* which promote guessing and have low diagnostic power, *leading questions* which contain a specific right answer, and cue-less *tugging questions* which often follow incomplete answers: "Tell me more." "Yes …?" (Good & Brophy, 1978). Choice, yes-no, and leading questions are often simple to answer and may be useful for low-achieving or shy students, but these kinds of questions should be limited to warming up and helping students respond to more substantive questions. Armstrong and Armstrong (1977) describe one effective use of leading questions in art teaching, showing how teachers may provide cues, mention important information, or require students to organize their observations and responses in a certain ways (for the purposes of instruction, to lead students to examine, classify, and describe phenomena and effects.

When students have difficulty responding, teachers should simply re-phrase the question in such a way that it contains more specific information about the desired response, rather than posing vague *tugging questions*. *Rhetoricals* may be used to set the direction of the daily lesson: "Can you remember what we talked about last week?" (Armstrong & Armstrong, 1977). Rhetoricals may also be used to convey what are actually commands: "Will you please put away the paints and brushes?" (Wolf, 1987). *Rhetorical correctives* covert commands designed to dissuay undesirable behaviors, are completely unrelated to the content of the learning task ("Why aren't you paying attention? or "Did you do the assignment?"). Such questions are counterproductive in class discussion sequences (Wolf, 1987). *Interrogatives* — questions which are self-evident ("What color is your shirt?" or "What did I say?") — are phony and unlike real discourse outside the school. Like rhetoricals, these kinds of questions should be used sparingly. *Solicitations of students insights and opinions are more authentic, more interesting, and more engaging for both teachers and students.*

7. *A climate for inquiry.* Discussions directed by teacher questions are a special type of classroom interaction in which the content of each student's contribution should be related to the content of their peers' contributions and in which a sequence of responses centers around something students find interesting. Dennie Wolf (1987) maintains that questions should be posed in a "conversational" manner and approached as an opportunity for an exchange of information, rather than imposed as oral quizzes or information checks. Wolf suggests that questioning cycles can have a life-course which can grow, unfold, and extend for weeks. In

her conception, teachers can create a climate for inquiry by responding thoughtfully to students, building depth gradually, keeping complex questions alive by returning to them again and again, reconsidering them from fresh perspectives, and encouraging students to pose their own questions.

Some concerns about classroom questioning cycles. Studies of classroom question/discussion sessions indicate that only a few students are interacting with the teacher while the others play the roles of audience members or passive listeners, sitting nicely and listening (Doyle, 1986). Studies also indicate that students most likely to receive no feedback after responses are generally low achievers. Yet low-achieving students are also the least likely to know if their answers are correct (Good & Brophy, 1978). Observations of teachers' question-and-response behaviors are contrary to teachers' own reporting to researchers of their behaviors and indicate that classroom questioning cycles can be exclusive. They can easily become the "private preserve of a few — the bright, the male, the English-speaking" (Wolf, 1987). Teachers need to be more cognizant of *who* is responding and how they interact with all students.

Cooperative Learning

Cooperative learning is an indirect strategy for fostering group inquiry. Cooperative learning refers to a range of instructional approaches which put students together on particular academic/social tasks or goals set forth by the teacher (Slavin, 1987, 1990). Several differences distinguish cooperative learning from other strategies involving groups:

- Students are grouped heterogeneously (in terms of ability, gender, ethnicity, and socioeconomic status) rather than homogeneously (Johnson, 1981).

- Achievement of the group goal is *dependent* on the individual learnings of all group members (Johnson, 1981).

- Structures are put into place by teachers to foster *active helping of others* (Slavin, 1987, 1990).

Cooperative learning is different from peer-tutoring in that all students learn the same material, there are no explicit academic hierarchies within or between groups, and the content under study is usually provided by the teacher. Finally, cooperative learning incorporates both direct and indirect teaching strategies. It involves the transmission of information from teachers to students as well as the communication of ideas between students.

Cooperative learning approaches rest on fundamental assumptions coming from developmental and motivational psychology and from the work of specialists in these areas such as Piaget and Vygotsky (Slavin, 1990). Research suggests that collaborative activity spawns *cognitive conflicts*, as students at slightly varying cognitive levels come together. These interactions then lead to cognitive growth. Peer communication develops desirable social and intellectual processes such as participation, argument, verification, criticism, and problem solving. Classroom studies demonstrate that effectively managed differences of views among students (controversies) promote high quality and more creative problem solving and decision making (Johnson, 1981).

Cooperative learning strategies are currently used at all grade levels in math, social studies, and reading-writing programs. Adaptations to visual arts teaching of Slavin's and Johnson's recommendations would be relatively easy, and variations of this strategy are already in place in many art programs. Students are frequently brought together to focus on a group project such as the construction of a mural or a quilt. Similarly, students work together on art historical and interpretive tasks such as the development of stylistic time lines, the analysis of personal responses to artworks, small-group critiques of one another's works, or considerations of puzzling controversies in the art world.

Socratic Dialogue

Socratic dialogue is a confrontational mode of discussion in which the teacher asks students to take a position or render a value judgment. The teacher probes students' statements for definitional, factual, and valuational clarity. The teacher then challenges the assumptions underlying students' positions by revealing their implications.

Although Socratic dialogue is confrontational, the teacher's reactions are not evaluative in the sense of approval or disapproval. Rather the questioning of evidence and assumptions are tendered with supportiveness (Joyce & Weil, 1980). The substance of students' comments becomes the focus of subsequent discussions. To follow a line of reasoning to an acceptable conclusion, the teacher should probe one student's opinions at length before challenging others. Sometimes it is advantageous to let students run into some "dead ends," provided that students have previously experienced successes with the material (Wlodkowski, 1984). Wlodkowski maintains that teachers should permit "a humane degree of student mistakes and frustration" (p. 104).

Jurisprudential inquiry was developed to help students to learn to think systematically about critical issues and public policy questions in society and to help them analyze alternative positions about them. Like Socratic dialogue, jurisprudential inquiry focuses on students' reasoning and communication skills. In jurisprudential inquiry, students are asked to assume a stance on issues that reflect the fundamental values of a democratic society as these ideals conflict with other positions also important to society. The goal is for students to develop the most clearly articulated and defensible position possible. Jurisprudential inquiry may be combined with role-playing to provide a challenging and highly interactive examination of issues. Using a Socratic or dialectical style of discussion, important legal, ethical, and social issues become the content and focus of instruction along with general reasoning and debating skills. Joyce and Weil (1980) present a good overview of this teaching strategy.

Synectics

Synectics is an instructional strategy designed to involve individuals and groups in the processes of free exploration, unencumbered by the rules of logic, followed by conscious and deliberate decision making. The term "synectic" comes from the Greek language and means *bringing different things into unified connection* (Joyce & Weil, 1980). Synectics utilizes analogies, anomalies, chance occurrences, conceptualizations, ciphers, metaphors, myths, paradoxes, performances, and puns (Roukes, 1988). Nicolas Roukes describes synectics as a form of creative thinking that combines imagination and analogical thinking in order to transform commonplace, familiar events into new and unusual structures.

In contrast to views which cast the creative process as mysterious, innate, confined to art making, and unteachable, synectics is based on the belief that creative invention is similar in all fields and that individuals and groups can understand and learn the basis of the creative process. The psychology of creativity supports these assumptions. First, it is generally believed that creativity can be enhanced by bringing the processes involved in creative thinking to consciousness. Second, normal linear and logical patterns of thought may be temporarily suspended to allow for the free interplay and open-ended exploration of fresh ideas. A strong emotional component underlies this kind of activity. Third, the formation of ideas in many areas relies on nonlinear mental processes *in combination with* analysis and logic, decision making, and technical competence (Joyce & Weil, 1980). See Joyce and Weil (1980) and Roukes (1988) for detailed descriptions of this teaching strategy.

Instructional Planning, Skills, and Goals: Fostering a Climate for Inquiry

Joyce and Weil believe that teachers can acquire a greater repertoire of instructional skills and that they can assume a more active role in conceptualizing learning tasks. For art teachers too often this role is relegated by default to inappropriate or outmoded instructional practices (passed down to teachers in arcane and out-of-touch teacher education programs); from lessons and activities modeled by college and university professors who do not know the first thing about children or schools; or from project ideas picked up en route to the art room from friends colleagues, or flashy curriculum publications. Art teachers may string together collections of art projects and assume (often after the fact) that deeper goals are reached. Sometimes, when asked, they articulate those goals. In relying on these sources and planning in reverse, they give up the opportunity to create the kinds of instructional programs that foster the goals they really value.

This chapter, along with Chapter 3, summarizes some of the more popular instructional methods and strategies in use today. Teaching methods may be combined to add depth and versatility to instruction. For example, lectures may be combined with discussions and demonstrations; lectures, demonstrations, and discussions may be combined with games and independent projects. Inquiry training may be combined with virtually every other method and strategy. Teaching strategies may be combined with each other and with different instructional methods. For example, you might use a questioning strategy in a specific learning episode, but as one in many strategies that contribute to a discussion. Regardless of methods and strategies employed, it is important to remember that all good lessons begin with a stimulating introduction and close with an insightful review.

The best teaching methods and strategies are those contributing to a climate that fosters self-confidence and encourages critical self-inquiry and self-reliance. The essential ingredients in such a climate are competence and trust. The real question is not whether students appear to be busy on tasks or free to discover and invent, but whether they feel safe to take risks, whether they are willing to engage unfamiliar conceptions and connect those ideas to what they already know, and whether they are provided necessary conditions to learn *how* to learn.

— 5 —
Learning and Motivation

It is between the ages of ten and seventeen
that youth exhibits both the greatest enthusiasm
and the greatest idealism. It is for this period
of their lives that we must provide them
with the best possible instructors and leaders.
For once youth has been won over to an idea,
an action like that of yeast sets in.
(Hitler's Table Talk, *cited in Davies, 1981)[1]*

Research on learning dominates inquiry in education, although most educators now agree that a learning theory cannot substitute for a theory of instruction (Lamm, 1976). The focus of a theory of instruction is on teacher attitudes and practices which give rise to learning in pupils (Lamm, 1976). However, because the purpose of instruction is learning, interest in the deliberations and methods of teachers involve, directly and indirectly, the study of learners. A theory of instruction is a theory in search of results, as seen in student learning.

Some Principles of Learning

Individuals learn in many ways: experience and reflection, conditioning with reinforcement, intuition, introspection, trial and error, imitation, verbal association, cognitive reorganization, and logic — inductive and deductive (Charles et al., 1978). Certain factors in the learning situation are known to speed,

[1] See author's note on page 60 about the use of this quote.

strengthen, or enhance learning: *clarity and organization, familiarity and concreteness* of material, *appropriate practice* with *corrective feedback, positive reinforcement,* and *usefulness* of the information (Charles et al., 1978). Clarity depends on the use of words, symbols, and gestures whose meanings are understood and the judicious selection and limitation of information. Organization facilitates meaningful learning by providing a coherent structure, so that ideas may be connected in meaningful patterns of thought. Materials organized in such a way that a pattern is discernible are easier to remember.

Learning requires episodes short enough in duration to avoid informational overload, long enough for assimilating and accommodating of new information, and with appropriate amounts of time for sorting and review (Charles et al., 1978). Learners better remember material that has been presented at the beginning or at the end of a lesson or that has been reinforced by repetition and review. Material consolidated and summarized is remembered more than material presented once. Overlearning is effective in that it provides continued practice with particular material after the point that it has been learned, and until it becomes automatic, habitual, or second nature (Davies, 1981).

Instruction does not guarantee that people will learn, and learning does occur without instruction. Learning is enhanced when learners want to learn and when they assume responsibility for their own learning (Gorman, 1974). Learning is deepened when the learning situation provides opportunities for applying learnings in as realistic a situation as is feasible (Gorman, 1974). Learners are more highly motivated when they understand and accept the purposes of the learning situation (Charles, et al., 1978). Meaningless material is difficult to distinguish and interpret and is often regarded as "noise" (Davies, 1981).

Material presented in a vivid, colorful way is more easily remembered (Davies, 1981). Positive reinforcement promotes learning, punishment diminishes the capacity to learn. Unpleasant situations promote learner withdrawal (Davies, 1981). Reinforcements, positive and negative, come not only from the instructor, they come from peers and from the learner's own self-concept (Gorman, 1974). A sense of personal worthiness is essential to a successful school experience. Learners who believe they are capable are more successful than those who do not have confidence in their abilities. A sense of personal worth cannot be turned on and off. It can, however, be shaped and enhanced in school settings (Davies, 1981). Finally, learning can be right and learning can be wrong. People learn

bad habits as easily as good ones (Davies, 1981), and bad habits must be unlearned. Merely overteaching does not ensure that incorrect student conceptions will be replaced with desirable conceptions, rather students must be informed that their conceptions are wrong and why, before attempting to replace old knowledge with new.

Domains and Dimensions of Knowledge

Although learning is often spoken of as a single thing, learning occurs, sometimes simultaneously, in different knowledge domains. Some educational psychologists believe that there are three broad domains of knowledge: cognitive, affective, and psychomotor (Charles et al., 1978). Howard Gardner (1993) poses seven domains, calling them forms of intelligence: linguistic, logical-mathematical, spatial, musical, bodily-kinaesthetic, interpersonal, and intrapersonal. Each of these domains, Gardner argues, are unique in their nature and role in human development, and each require educational intervention for their development beyond their most basic, primitive levels.

Learning theorists describe knowledge somewhat differently — according to its explicit and tacit dimensions (Davies, 1981). *Explicit knowledge* is clear, precise and directly communicable through words. *Tacit knowledge* is nonverbal, nebulous, and personal, although tacit knowledge can sometimes be demonstrated indirectly through performance. Peter Davies believes that teachers need to acknowledge and tap into students' tacit knowledge. He suggests the use of varied presentational methods, media, and instructional approaches that require active participation from students to put their tacit knowledge to use.

John Bruer (1994) explains that teachers can make tacit knowledge overt and explicit by focusing on basic metacognitive skills. *Metacognitive knowledge is how one thinks about thinking.* Basic metacognitive skills include the ability to predict the results of one's own problem-solving actions and to check the results of one's actions (Did it work?), to monitor progress toward a solution (How am I doing?), and to test how reasonable one's actions and solutions are against the larger reality (Does it make sense?). Teachers may teach metacognitive skills by *modelling mental operations* (or cognitive processes), thinking out loud during demonstrations, and by *dialoguing* with students in joint learning and problem-solving activities.

Motivation and Learning

How do you interest lazy and careless pupils? Answer in full
*[emphasis added]. Question from the California State Board
Examination for elementary teachers, March 1875.
(Cited in Shulman, 1986)*

Motivation and learning go hand in hand. Motivation is the desire or drive to pursue a particular activity, mental or physical. Abraham Maslow (1968) believed that every person is motivated to achieve her or his unique potential, to grow into what he or she can become. He referred to this process as self-actualization. To realize that growth, individuals strive to satisfy their fundamental needs and interests. Motivation in this sense is an inner drive toward personal growth.

Sources of Motivation

Incentives to participate, to pursue learning, and to extend effort toward the mastery of new or difficult material are shaped by teachers' motivational strategies. Studies of student mediation of instructional programs have resulted in surprising findings with regard to student needs and motivations. Studies indicate that classroom work is seen by students as an exchange of performance for grades, that the goal of seat work is *completion* rather than *comprehension* of the material, and that low-achieving students accept confusion as a condition of seat work, while high-achieving students treat the condition as problematic and seek help immediately (Shulman, 1986). Studies of extrinsic rewards systems, student intrinsic interest, and students' personal satisfaction with their performance suggest that some motivational strategies work better than others. Key findings in these studies indicate that *success is a key factor in motivation.* Student motivation and achievement are strongly linked to their prior successes in the classroom, and their perception of themselves as capable of achieving future success (Brophy, 1988).

Extrinsic motivation. Some education professionals believe that extrinsic rewards and reinforcers may enhance motivation. Extrinsic rewards may be social (praise, recognition), symbolic (grades, privileges), or tangible (markers, stickers, treats, parties, field trips). Contrasts and changes of pace provided by extrinsic reward systems add impact and interest to material. But according to Ashton and Webb (1986), extrinsic rewards and competition

have limited effectiveness as an incentive and may diminish the motivation of those who believe that they cannot compete with their more competent peers. Research indicates that extrinsic rewards given regardless of performance tend to reduce interest, whereas rewards given for performance signifying competence sustain high interest (Bandura & Schunk, 1981; Brophy, 1983b). Finally, rewards may reduce self-esteem if they are perceived as manipulation. In some situations certain student performance is valued by teachers not for its own sake or for the positive benefits it provides in future performance, but because it is desired for other reasons, such as control of behavior.

Intrinsic motivation. Intrinsic motivation is internal to the student, spurred on by each student's inner states (curiosity, arousal by certain stimuli, and a desire for pleasant experiences) and fostered by qualities inherent in the required task (stimulating, interesting, enjoyable; Brophy, 1983b). Curiosity comes into play in relation to objects, events, and ideas that are unusual, humorous, animated, suspenseful, or problematic (Charles et al., 1978). Students' *self-efficacy* — conceptions of their own competence — also plays a mediating role in intrinsic motivation. Ashton and Webb (1986) surmise that the basis for human motivation is the belief that one's actions produce a result in the environment. This phenomenon, termed *personal causation*, is fundamental to intrinsic motivation. The extent to which students perceive themselves as causal agents in the achievement of particular goals influences their intrinsic interest and their efforts (Brophy, 1983b).

Motivation to learn. Brophy (1983b) further distinguishes intrinsic motivation from the motivation to learn. Intrinsic motivation refers to the affective aspects of motivation — liking or enjoyment of an activity. But such motivation may accompany performance and participation in activities with no desire to learn, and learning can occur without enjoyment. Motivation to learn means the desire to pursue learning for the sake of learning. It refers not only to the motivation that drives later performance but also to the motivation underlying the covert processes that occur during learning. Motivation to learn is an enduring disposition to view the process of learning as valuable and to take pride in the outcomes involving experiences associated with knowledge acquisition or skill development.

Numerous prescriptions for teaching have been inferred from research on motivation. Motivation theorists now believe that excessive use of extrinsic reward systems for successful learning may inhibit student potential, whereas proximal goal and standard setting, coupled with systematic reinforcement and feedback, may foster the desire to pursue learning and lead to stu-

dent independence and responsibility for their own learning. The following suggestions, selected and condensed from the literature on motivation and learning theory, offer practical, sensible strategies for motivating students toward these aims.

1. **Avoid conditions that inhibit learning.** Rather, maintain a safe, structured, supportive, caring environment. Students are unlikely to learn if the classroom is chaotic or if they feel anxious or alienated. The teacher must organize and manage the classroom as an effective learning environment in such a way that encourages students to take intellectual risks without fear of criticism or making mistakes.

2. **Design instruction for appropriate levels of challenge difficulty.** Notions of optimal difficulty are central to most theories concerned with learning. Students get bored if tasks are too easy and may become frustrated if tasks are too difficult. In either case, motivation to continue is diminished. Studies indicate that in difficult tasks, students' knowledge of some subskills raises the assurance that they might be able to perform successfully. When students gauge their progress against distal goals, interest may decline, even though skills are being developed. In other words, interest lags behind success (Bandura & Schunk, 1981). Awareness of these subtleties in student motivation, and accurate knowledge on the teacher's part of student ability levels is crucial to effective instructional design.

3. **Select meaningful learning objectives.** Teachers should select activities that teach knowledge or skills perceived by students as worth learning either in their own right or as a step toward a higher worthwhile objective. Material learned but not needed or material too vague or abstract is not likely to be mastered and/or retained.

4. **Teach proximal goal setting.** Certain properties of goals such as specificity, level, and proximity enhances the motivation to continue. The satisfaction achieved when goals are reached also enhances further effort (Bandura & Schunk, 1981). Proximity, for Bandura and Schunk, has two significant dimensions: how far into the future individuals are able to project goals and how closely subgoals relate referential internal standards to ongoing performance. Both of these dimensions affect self-motivational mechanisms. When performances are measured against lofty distal goals, the large negative disparities between standards and attainments are likely to diminish self-satisfaction. When individuals can project a need for attaining a long-term goal into the distant future, and when individuals can also attain moderate subgoals that lead to the attainment of those long-term goals, motivation to continue is enhanced.

5. **Teach performance appraisal and self-reinforcement skills.** In social learning theory, self-directness operates through a self-system that comprises cognitive structures and subfunctions for perceiving, evaluating, monitoring, and regulating behavior (Bandura & Schunk, 1981). An important cognitively based source of self-motivation relies on the intervening process of goal setting and the self-evaluative reactions to one's own behavior (Bandura & Schunk, 1981). This process operates through internal comparison processes and requires personal standards against which to evaluate ongoing performance. By making self-satisfaction conditional on a certain level of performance, the individual creates self-inducements to persist in his or her efforts until performance matches internal standards. But students' sense of self-efficacy and competence are dependent on accurate self-judgment and self-regulation in their attempts to learn unfamiliar or difficult material. Studies indicate that students who are able to guide and judge their progress toward proximal subgoals and who tend to be highly accurate in their self-appraisals are most successful.

6. **Help students recognize linkages between ability, effort, and outcomes.** Research on causal attributions for performance suggests that effort and persistence are greater in individuals who attribute their success to internal, controllable causes rather than external causes (Ashton & Webb, 1986). Better performance is associated with a tendency to attribute success to a combination of sufficient ability and reasonable effort, and to attribute failure to insufficient effort (only if that has been the case) and/ or confusion about what to do or reliance on an insufficient strategy for doing it. Students who perceive themselves as incapable, or who attribute success to high effort alone, are not as successful as students who attribute their academic successes to a combination of ability and effort. This is true for both high-ability and low-ability students.

7. **Program for success.** *Students must see themselves as capable of succeeding.* Effort and persistence are greater in individuals who set goals of moderate difficulty level, who seriously commit themselves toward those goals, and who concentrate not on avoiding failure but on achieving success (Brophy, 1987). The simplest way to ensure that students expect success is to make sure they achieve it constantly. Success on difficult tasks depends on the teacher's ability to diagnose student prerequisite knowledge and skills, to prepare students through advance instruction, and to assist students during learning efforts through guidance and feedback.

Teachers' Attitudes and Students' Academic Success

The problem with a great deal of instruction is the illusion that learning is taking place (Davies, 1981), or conversely, when learning does not take place, it is the student's fault (Ashton & Webb, 1986). Critical issues surrounding teaching include complex and often unexamined notions about students' capacities to learn and about the underlying causes of success or failure in the classroom. *Students do not arrive at their schools thinking that they are failures — they learn this in school* (Persell, 1993). Studies of students from lower socioeconomic strata of American society, ethnic minorities, and female students indicate that most students come from parents who think of their children as capable and intelligent and that these students arrive at school with high self-esteem. These studies demonstrate, however, that the older these students are and the longer they spend in schools, the more their self - esteem plummets (Persell, 1993).

Research has documented just how complex and problematic issues of teacher attitudes and expectations really are. For example, Rosenthal and Jacobson's landmark study *Pygmalion in the Classroom* (1968) linked student achievement to teachers' beliefs about particular students' ability to learn. Teachers' notions were based not on systematic observations of students but on preconceived beliefs about student abilities to learn. Rosenthal and Jacobson found that teachers subtly communicated their positive and negative expectations to students through patterns of praise, questioning, tone of voice, and opportunities to learn. More disturbing in their study was the finding that teachers' expectations and behaviors were often based on gender and race. This phenomenon became known as the *expectation effect*: Teachers acted differently toward students for whom they had different expectations. Differences in teacher expectations and subsequent behaviors led systematically to differences in student successes in the classrooms, *independent of student abilities.*

Teacher efficacy (a belief in their own ability to successfully teach the students in their classes) also affects student success in the classroom (Ashton & Webb, 1986). In a series of multischool, multiteacher studies conducted by Ashton and Webb on teacher efficacy, student achievement was positively or adversely affected by the teacher's sense of efficacy. Student achievement, for both low-achieving and high-achieving students, was significantly higher in the classes of high-efficacy teachers. Most troublesome, however, were the explanations offered by low- and high-efficacy teachers. Teachers with a low

sense of efficacy reported that student lack of achievement was best explained by student (a) lack of ability to learn, (b) insufficient motivation (c) behavioral and character deficiencies, and (d) poor home environments. In sum, teachers with a low sense of efficacy did not share responsibility for the academic failures of their low-achieving students. They expected their students to fail and were not surprised when that expectation came true. The problem was attributed to genetics, the home, or the students themselves (Ashton & Webb, 1986).

Teachers with a high self-efficacy were more likely to define low-achieving students as reachable, teachable, and worthy of teacher attention and effort. In fact, many high-efficacy teachers took pride in their ability to teach the students their colleagues defined as unteachable. They saw student problems as surmountable and felt that it was partially their responsibility to help students over the hurdles that life had placed before them (Ashton & Webb, 1986).

Studies also confirm that teacher attitudes are not formulated in a vacuum. Rather teacher efficacy and attitudes towards learners are developed and sustained in their schools (Ashton & Webb, 1986). Studies of institutions suggest that the single most important factor in fostering successful students is the *school ethos*, its collective characteristics and distinguishing habits and customs. A successful school is not the result of any specific mix of teaching methods and student ability levels. Rather, it is the result of cumulative, positive factors such as high expectations for student achievement, clear incentive and reward systems, continual monitoring of student work, and providing students with corrective feedback. Studies indicate that when school personnel collectively expect and value student achievement, when they communicate those expectations and values to students, and when they are intolerant of misbehavior, students are likely to learn more (Ashton & Webb, 1986). In short, when individuals in the schools (teachers and administrators) truly believe that all students can learn, truly want all students to learn and support learning in positive ways, students learn.

Some Final Thoughts About the Relationsips Between Teaching and Learning

For many American educationists, the essential task of teachers centers around understanding how students learn in order to have a better "fit" between teach-

ing and learning (Bruer, 1994), which means extensive research on teaching and learning in differing knowledge domains. For others, teaching consists of tapping into students' innate needs, desires, and curiosities (Wlodkowski, 1984); recognizing students where they are; facing the realities of children's lives; and embarking on a mutual path of communication, discovery, and resolution (Dennison, 1969). This is accomplished not through distancing and the abstract rhetoric of bureaucrats and technocrats but head on, face to face, in big and small communities (Dennison, 1969).

Just as teachers spend a great deal of time assessing students, they spend a great deal of their time sizing up teachers. Generally, students of all ability levels, social classes, and ethnic groups want us educators to know what we are talking about and to know what is going on in the world. They want us to speak clearly and concisely, to maintain a safe ordered learning environment for them, and to treat them with respect. Finally, they want us to care about them. In our search for the most powerful theories of learning, the best methods of teaching, the latest research on learning, the best methods of teaching, the latest research on motivation and learning styles, we tend to overlook what we already know — that children of all ages flourish in a loving environment.

Author's Note: The quotation that opens this chapter (p. 51) becomes shocking and repugnant when one realizes its source. For Hitler, neither an educator nor an authority on child development, teaching was synonymous with indoctrination and furthering the goals of the state. The consequences of such extremism and radical nationalism have been forced upon many peoples throughout this century. Thus, educators must be ever cognizant of the fact that powerful leaders often view teachers and schools as essential to their aims. Here in the United States amid competing conceptions and vigorous debates over the aims and methods of education, the alternatives — including the coalescing of power and authority into one single vision — are fraught with peril. The choice between pluralism, as chaotic and disturbing as it is, and totalitarianism seems obvious yet many local school districts are experiencing attempts by well-organized groups to challenge and co-opt the decisions made by professional educators. These challenges are made not on the basis of research, advancements in thinking, or systematic sociological studies but on a particular view of the social and moral order. Teachers must take an active part in the debates so that their expertise and vision for the community may inform the political processes affecting educational policy.

— 6 —
Classrooms

*Nothing on God's earth could
have prepared me for this!
(Remarks of a first year teacher,
cited in Dawson, 1984)*

The classroom is often described as a complex and fast-paced environment, much of which escapes or remains hidden from detection. Educationists believe that two kinds of transactions make up classroom life: academic content — the *intended* or *manifest curriculum* — and social aspects — sometimes referred to as the *hidden curriculum* (Shulman, 1986). The academic content of a subject consists of particular sets of concepts, skills, strategies, processes, or understandings. The organizational structures define and shape student interactions with the academic content. Shulman continues; "The dual general purpose of transmitting mastery of the contents of a curriculum, comprising many subjects, skills, and attitudes, and of socializing a generation of young people through the workings of the classroom community define the core of classroom life" (1986, p. 7). Recent inquiry in teaching and learning seeks to reveal the hidden qualities of classroom life.

Research on classroom life goes by different names: classroom climate studies, classroom ecology research, transactional analysis, naturalistic inquiry, and school ethnography. Researchers interested in the "ecology" of the classroom describe the interactional processes, task systems, and systemic or organizational structures that comprise classroom life. Classroom ecology research attempts to describe dimensions of classroom interactions in relation to larger sociological and cultural systems. This research ranges from language analyses of transactions within small groups of students to studies of the relationships between communities and their schools. Interest focuses on the *reciprocal* and *interrelated* communicative, social, and contextual transactions themselves. Previously unobservable processes (attitudes, feelings, thoughts) are treated as primary sources of data. Students are viewed as differ-

ing vastly in terms of how they handle the academic and social agendas of the curriculum and how they are perceived and subsequently treated by their teachers. Students' personal meanings and interpretations are studied along with their performance on academic tasks. Teaching effectiveness, in this line of research, is seen in terms of the felt qualities of their classes; the degrees of equity in the treatment of students; and the ability to negotiate the complex interrelationships between students, classes, and their schools.

Classroom Life From a Student's Perspective

A "climate" develops as people spend time together. Classroom atmospheres are seen by students along several continuums: highly formal to informal, tense to relaxed, suspicion to trust, indifference to loyalty, inhibition to freedom of expression, isolation and clique-formation to total group cohesion, and frustration to satisfaction, to name a few (Gorman, 1974).

Studies conducted by Patricia Ashton and Rodman Webb (1986) describe the ramifications of teachers' attitudes on student achievement. In every rewarding teaching situation described by teachers with a high sense of efficacy the following commonalities were identified: (a) students shared the teacher's goals for the class, (b) students shared the teacher's definitions of what it means to be a teacher and to be a student, (c) the students and the teacher were willing to help one another achieve the class objectives and to fulfill the responsibilities of their respective roles, and (d) both students and the teacher shared a sense of pride in what they had accomplished. High-efficacy teachers greeted their students at the door and talked with them informally before class. When the bell rang, they got their students' attention and went directly to work. They kept students on track throughout the lesson. They did not use class time to grade papers, did not leave the room, and did not socialize with adults during class time. Assignments were checked and records were kept on student progress.

In these same studies Ashton and Webb found that teachers with a low sense of efficacy called on low-achieving students less often, seldom pushed or encouraged such students to do their work, do it well, and turn it in on time. Frequently the work assigned to such students appeared trivial and designed to keep them busy so the teacher could teach the "brighter ones." Some teachers even engaged in what Ashton and Webb termed "excommunication tactics," sending low achievers to the library or to another part of the room to do work

for which no instruction was provided, or which would not be monitored or evaluated. Students in these studies were well aware of their teachers' attitudes toward them and were heard to comment on being considered "dumb" by their teachers. Ashton and Webb argue that when teachers sort and stratify their classes according to ability and give preferential treatment (more instruction, more appropriate praise and corrective feedback, more assignments) to some while neglecting others, all students are likely to learn where they stand in the teacher's pecking order. Ashton and Webb's studies confirm that teachers' sense of personal and professional competence and power, classroom ethos, and student achievement are woven together in classroom life.

Likewise, student motivation and learning are strongly related to their attitudes, feelings, and needs, which in turn effect the *quality* of interrelationships and interactions occurring in learning situations (Wlodkowski, 1984). As educational leaders in the classroom, teachers have the greatest responsibility to identify student needs and attitudes and to foster positive classroom interactions (Wlodkowski, 1984). To this end Wlodkowski recommends the following strategies.

1. *Use supportive communication behaviors to facilitate a positive trusting climate and to reduce defensive, inhibiting student behaviors.* Use descriptive speech instead of judgmental speech. Use a "problem orientation," conveying a desire to collaborate mutually toward conflict resolution, rather than controlling speech which suggests that students are immature or inadequate. Express empathy and respect, rather than conveying a neutral or noncaring position. Avoid communication that implies superiority, rather exhibit behaviors that communicate notions of equality, accepting student opinions and working with them to solve problems and plan activities.

2. *Use a cooperative goal structure to maximize student involvement and learning.* A cooperative goal structure is one in which students, rather than focusing solely on teacher-centered tasks and working in isolation or competing with one another, work together on mutually shared interests and goals.

3. *Make group decisions by consensus, rather than by "majority rule."* Students and teachers must be able to state their positions clearly but must be equally able to listen to others' reactions and ideas. All members must participate. Discussions should probe underlying assumptions. Agreements should be based on the logic and fairness of ideas and not on an effort to avoid conflict. When stalemates occur, groups must seek out the most acceptable alternative for all.

4. *Use climate surveys to diagnose your classroom atmosphere.* Construct climate surveys collaboratively with students. Discuss findings with students.

5. *Use self-diagnostic questioning procedures to identify and reflect upon how your behavior influences the classroom atmosphere.*

Student-school relationships are defined by cultural, economic, and political conditions in the world. The dynamics of community life, including a growing public concern about violent crime, court rulings, health problems (including drug and alcohol abuse and AIDS), and changing family situations affect life in the schools. Students are very much concerned about safety, vandalism, violence, health, and peer relationships. David Henley (1991) asserts that "never before have so many increased their standard of living while others languish in poverty". ..."Children raised in dangerous environments increasingly turn to gangs, crime, drugs, sex, and other destructive forms of self and societal abuse. For educators working within inner cities, these chronic problems have become the norm" (1991, p. 17). Middle-class students living in the suburbs, Henley observes, also have their share of difficulty, where "divorce continues to be rife — splitting parents, grandparents, and children apart emotionally, financially, and geographically. Substance abuse and co-dependency occur with frightening regularity, while sexual, physical, and emotional abuse is also rising in frequency" (p. 18). Many student problems and concerns go beyond the scope of the school, yet these problems become part of the complex of classroom life. Students' pervasive social and economic problems become, ultimately, problems that teachers have to deal with. Studies at the national, state, and local levels indicate that during a school year approximately 20% of all students exhibit some form of notable emotional or behavioral problem attributable to family and community life. Teachers need to develop knowledge and skills in both cognitive and affective areas to cope with the emotional problems students bring to class (Henley, 1991). At the very least, teachers need to become aware of the realities of children's lives.

Classroom Life From a Teacher's Perspective

Classroom climate, for teachers, can mean many things, and teacher mediation studies, to some degree, have captured some of these perceptions. Teachers' perceptions of the pace of classroom activities, the degree of ease with which they are able to teach and manage classrooms, their perceptions of the

manner in which students view and respond to their teaching all affect the day-to-day feel of *being* in the classroom.

A closer look at classroom life reveals that teachers do most of the talking, generally about two thirds of it (Delamont, 1976). Students therefore spend a lot of time listening and expend effort trying to fulfill teacher requests. "It is a platitude," Dawson argues, "that every young person is a unique individual, but one all too easily buried by institutional necessity" (1984, p. 101). Imagine being a silent teacher. Teaching and talking are almost synonymous in the context of classroom life. What do teachers talk about? Teachers rate instruction as most important among their duties, and research shows that they do spend a lot of time on academic content. But contrary to assumptions that teachers and students are involved in academic transactions, only about 50% of teachers' talk deals with academic content. The other half deals with procedural/organizational concerns, classroom management, and discipline. Teachers' needs to maintain control comes from different sources: the institution, teachers' personal need for order, parental expectations, and, surprisingly, student expectations. Students *want* their teachers to manage their classrooms well and to maintain discipline.

Teachers communicate not only through talking, but through nonverbal modes of communication: variations in the pitch, tone, force, and timing of the voice; gestures, facial expressions, posture, body movements, and proximity; and sounds including sighs, laughter, groans, and hesitations (Davies, 1981). Albert Mehrabian estimates that only about 7% of the emotional impact of a person's message is conveyed through words (cited in Davies, 1981). Vocal elements contribute about 38% and facial expressions contribute 55%. Unlike written words, which can sometimes mask emotional content, spoken words carry and convey feelings. "Words mean whatever your body language wants them to mean" (Davies, 1981, p. 144). We may infer from these observations that students are reading, decoding, and interpreting teachers' nonverbal communications along with their utterances. Aspects of communication like enthusiasm or boredom, degrees of certainty, concern and disdain, approval, affection, frustration, and defensiveness, for example, are unknowingly communicated nonverbally by teachers and acted upon by students.

Studies of classrooms show that teachers may be engaging in a thousand interpersonal exchanges every day. Teaching is characterized by a *spontaneous* quality, a here-and-now urgency. In his book, *Life in the Classrooms*, Phillip Jackson (1968) observed the *immediacy* and *autonomy* that characterize teaching. Decisions are, by necessity, immediate, with no opportunities for "second opinions." The teacher is alone and in control, having sole au-

thority over many aspects of students lives: behavior; topics and modes of inquiry; seating arrangements; social interaction between students; access to curriculum resources and school materials; access to food, drink, rest rooms, and so forth. Negotiations are not between equal partners — teachers and students come to the classroom in very different bargaining positions. Some aspects of classroom life, like autonomy, are elements already in place before teachers or students enter the setting. They are part of the nature and structure of schools. Also, teachers attend not only to academic content and procedures; they must adapt instructions, materials, and processes to the individual needs and abilities of students. Every class is a mixed-ability class, not to mention a mixed-aptitude class and a class in which the quality of life outside the school is different for every child. Many observers have noted that classrooms are characterized by *multidimensionality*, the large quantity of events and tasks affecting one another in classrooms, and *simultaneity*, the overlap of events that must happen at the same time.

Professional Aspirations and ... Well ... Reality

A profession is in grave trouble when it does not protect the professional self-esteem of its membership, cannot retain the most talented people in its ranks, and does not develop the potential and increase the talent of those who work within it. (Ashton & Wcbb, 1986, p. 89).

Many teachers argue that the public holds unrealistic expectations for education. They maintain that they are faced with impossible working conditions making it difficult if not impossible to accomplish what the public demands. Teachers are also keenly aware of a lack of appreciation for the good things that take place in their classrooms and the extra efforts they exert on a regular basis on behalf of their students and schools (Ashton & Webb, 1986). In a survey conducted in 1981, well over 50% of the teachers surveyed indicated that public attitudes toward schools, the treatment of education by the media, low salaries, negative student attitudes toward learning, and the declining status of teachers have had a negative impact on job satisfaction and professional morale (Ashton & Webb, 1986, p. 39). For Ashton and Webb, and a good many others, the teaching profession is in decline.

The general problems of teaching just described are compounded in art teaching, where it seems that even fewer members of the public and, for that mat-

ter, colleagues in other fields of education understand or value what art teachers do. Laura Chapman (1982) and Wanda May (1989) are among the few academics who write about how it feels to be a teacher in a system of education that places little value on study in the arts. May and Chapman observe that art teachers are aware of the marginal status of the arts in the schools and its impact on students' opportunities to learn. May explores constraints on art teachers' deliberation, decision making, and curricular practice as these aspects interface with the construction of knowledge in the work place. These constraints include

- Viewing teaching as noble (unrewarded by extrinsic means such as status and income).

- Viewing teaching as women's work.

- The isolating cellular structure of schools, where professional dialogue with colleagues is difficult to initiate and maintain and release time to collaborate and renew is a rarity.

- Tensions between institutional goals (focused on mass achievement) and teachers' goals (which are focused on individual student accomplishments and successes).

- Art teachers' invisible workload (e.g., art on a cart).

- Student and institutional perceptions of art as "unimportant but fun."

- Teachers' interest in *activities over objectives* and *breadth over depth*.

- Art teacher beliefs about student abilities (e.g., "third graders can't learn art history").

- A technical-managerial mentality that pervades school thinking, including the devaluing of teacher expertise, wherein experts external to the classroom define and prescribe curricular and instructional programs. (May, 1989)

Studies of art teachers' descriptions of their work and, of classroom life reveal themes of dissonance, frustration, urgency, and compromise the minds and hearts of art teachers (Bullock & Galbraith, 1992). Art teachers share with their colleagues in other curricular areas a larger social climate where teacher-bashing is the name of the game. Teachers are held accountable for the most unreasonable expectations, the major one being that they can solve the ills of society by doing a better job, by being smarter, and by working harder. Other major sources of art teacher stress include

- Overcrowded and unsuitable classrooms (or in the case of too many K-5 art teachers, no classrooms of their own).

- Limited and poor-quality student materials and supplies and instructional resources.

- Diverse students with varying prerequisite knowledge, abilities, and personal problems.

- Unwilling and uninterested students who are advised into art classes by guidance counselors who conclude those students "cannot make it in the academic classes" (a common practice in high schools referred to as "dumping").

- Full inclusion (the mainstreaming of special needs students into the classes) without administrative or instructional support.

- Disruptive student behavior.

- A general lack of administrative and institutional support.

- Budget and program cuts and/or the ever-present threat of them.

- External pressures to add new material to an already overcrowded curriculum or to learn and employ unfamiliar instructional methods.

- A general feeling that teaching art is not well regarded in the schools, the communities, and in society at large.

Where does one begin addressing the problem of art teacher stress? The means by which art teachers can effectively deal with the sources of stress deserves a book, a lifetime of research, but not, apparently, in the academic literature. Research on children's social, cognitive, and artistic development and philosophical debates over what and how teachers should teach in light of this or that research, abound. However, research on the conditions of teaching art, art teacher mediation, and art teacher stress are scarcely acknowledged as one of the parameters of teaching and learning in art.

Many art teachers are certainly aware of the multitude of voices calling for them to make their programs of study comprehensive, integrative, outcome-based, multicultural, and gender-sensitive (Mims & Lankford, 1994). Furthermore, they are told that their curricula should promote environmental awareness; be technologically advanced; be responsive to diverse learning styles, individual needs, and aesthetic systems; and be socially relevant (Mims & Lankford, 1994). Overwhelmed by pressures to do more, to do everything, art teachers are often faced with a sense of inadequacy, guilt, and finally, anger with the frustrations that accompany these pressures. Sandra Mims and Louis Lankford observe that all of these pressures contribute to what they call "the myth of the super art educator" and argue that an art teacher's sense

of job satisfaction, in light of this myth, is directly tied to his or her sense of personal and professional accomplishment.

Mims and Lankford (1994) recommend that art teachers, rather than attempting to follow every curriculum and instructional trend, mandate, or innovation, simply make sound decisions based upon their own particular circumstances and sense of rightness and commit themselves to a few attainable changes and objectives each year. By making short-term and long-range plans that incorporate incremental changes and improvements each year, art teachers may gain that sense of pride and enthusiasm that comes with personal and professional growth, and avoid the stress of trying to do too much or make major changes all at once.

Identifying, Coping, and Changing the Environmental Conditions of Teaching

Minor or hidden sources of stress in the classroom often stem from immediate environmental conditions or negative interactions with students. A teacher's first task is to identify these subtle sources of stress. Environmental conditions may include room temperature, quality of light, air quality, room acoustics, room cleanliness, clutter, intercom announcements, and white noise (Susi, 1989). Some of these environmental conditions are relatively easy to manage, alter, or ignore. The organization and cleanliness of the room, traffic patterns, and room temperature may be adjusted in many cases (Susi, 1989). Other detrimental environmental conditions require more extensive efforts to alter or ignore. Teachers may not always be in a position to pursue issues of air and light quality or undue interruptions on the intercom system without the assistance of their local teachers' professional organizations. Some unhealthy and stressful environmental conditions are created by art projects, and the art teacher must decide whether lessons associated with these conditions are worth the effects. Regardless of their causes or sources, environmental sources of stress deserve occasional systematic attention. When conditions are without resolution, the best strategy is learning to *cope*. Coping is a decisive action to an identified problem. As such, coping reduces anxiety.

Other minor sources of stress include what Laslett and Smith (1984) call the *irritation factor*: time-honored ploys which students have used to gain distraction from their work. Four main student-created sources of irritation in the classroom are noise, equipment, movement, and chatter. Sources of irritating noises include coughing, feet shuffling, paper shuffling, the scraping of chairs, and, as mentioned in the previous paragraph, the natural sounds

that accompany the use of tools and materials. Tools and equipment loss ("Someone took my ruler," "I lost the needle tool"), or malfunction ("I can't help it if the art gum eraser keeps breaking into tiny little pieces," "someone put clay in the sink drain") are not only irritating but expensive. Movement, especially with the more fluid group activities, is particularly problematic for art teachers, where students' temptation to wander off, gossip, or disappear are greater than in more structured classroom settings. Chatter is especially noticeable in settings where students are encouraged to comment upon their work or to discuss their work together. Volume and the relevance of what is said can easily become matters of contention between teachers and students. Sometimes a sense of humor is the best response to varying sources of irritation. Managing materials distribution and storage in a systematic way, establishing procedures to regulate movement and social chatter, and diligent monitoring of classroom activities are necessary aspects of instruction. And even when student transgressions are deliberate and provocative, teachers must beware of too strong an immediate response.

Managing Stress: Prevention, Monitoring, Networking, and Journal Keeping

Left unchecked, mounting teacher stress has the potential to diminish and destroy the sensitive atmosphere or climate of the classroom. Research on classroom discipline indisputably indicates that the best strategy for minimizing student behavioral disruptions is establishing clearly defined procedures and expectations early in the school year. Continual monitoring and classroom maintenance are also necessary.

Prevention, in sum, is the best approach. Stress management seminars, developed with high-stress occupations in mind, focus on coping mechanisms, desensitization techniques, and some methods of conflict resolution. Recent writings suggest two strategies for dealing with stress and solving problems: *journal keeping* and *networking*. Keeping an accurate written account of discipline problems, with specific details about how both you and the students behaved during disruptions to the flow of classroom activities can reveal behavior patterns not readily apparent. Networking with trusted colleagues is also helpful in solving stressful, repeating encounters with particular students. Other strategies for analyzing stressful situations (a 12-step program so to speak) are given next.

1. **Identify the specific source of stress.** Is it related to concerns about classroom management, subject matter competence, resources, particu-

lar students, other teachers, school relations, or other personal (outside of school) concerns that impact school life?

2. **Think clearly about the problem.** Describe its history and dimensions. Separate it from other problems, and work on one problem at a time.

3. **Talk objectively about the situations that cause concern with someone you trust and respect (someone who can maintain some degree of objectivity).** Maintain a continued dialogue with that person until you feel that the problem is resolvable or that you can cope with it.

4. **Stay with the problem until a range of solutions can be conceptualized.** Refusing to address/analyze a problem often ensures its continuation. However, after considering options, one option is always to do nothing — to wait and see. Some problems do not always require direct intervention.

5. **Develop a strategy for either solving the problem or coping with the source of stress, and set these plans up in some order of priority.** Weigh the drawbacks and benefits of pursuing stronger courses of action.

6. **Write a descriptive account of the events that cause stress.** Keep a journal with dates and names; develop a history of recurring stressful events. Outline what actually transpires when the problem occurs. Develop a time line. Answer who, what, when, where, how, and why questions about the situation or event(s). Are the sources of stress environmental, behavioral, or institutional? What are the conditions in which stressful events occur, or who does or says what? How do they do or say it? When, where, and why?

7. **Look for patterns of behavior, your own and others', that emerge over time.** A written account helps you track patterns of thought, feelings, and behaviors that tend to be forgotten. Have your patterns of behavior been productive (did you accomplish your aims)? Why or why not?

8. **Describe exactly what you have done, said, thought, and felt in these situations.** Ask yourself the following questions: Why do I act, think, and feel that way? What underlies the conflict between what I expect and what actually happens? What do I really want from this situation: attention? recognition? respect? student learning?

9. **Describe what usually happens *just before* the stressful event occurs.** Then ask yourself: How do I *react*? What else might I do?

10. **If the source of stress is a student's disruptive behavior, determine what the student was doing prior to the disruptive behavior and why.** Then ask and answer the following questions: What was I doing at the time? How did the class react to the students' behavior? How did I react to the student's behavior? How did the class react to my behavior? How did I manage or react to the behavior (or behavior similar to it) when it happened before?

11. **Look for repeating patterns of behavior (your own and others') that contribute to stressful encounters.** Consider the situation from the perspective of other participants. What motives and objectives contribute to their behavior? Reexamine your priorities in terms of others' perspectives and aims. Was it the student or the behavior that I was reacting to? What positive attention did I give the student prior to the event?

12. **Stay away from the "burnouts" (teachers who have given up).** *Ideals* are easily shattered, but they will last a lifetime if properly cared for. Burnt-out teachers know everything that is wrong with the profession, their students, the school, the community but they have no solutions. Associate, instead, with those teachers who have hope for the future, show a reasonable sense of how to manage the complexities of the profession, and look forward to being with their students.

Classroom Life:
How Was Your Day Today?

The notion that it is impossible to understand an organism outside of its environment is now generally accepted and provides a broader and, hopefully, more informed framework for understanding the parameters of teaching and learning. Teaching activities take place in any number of contexts, "surrounds" as Shulman (1986) calls them, which shape the world in which teaching and learning occur. A theory of instruction must begin with the assumption that the environment is the primary variable accounting for what the learner learns (Englemann & Carmine, 1982). For teachers and students, that context or environment is the classroom. Early classroom ecology research demonstrated how schools and teachers failed to serve certain students by virtue of their gender, ethnicity, socioeconomic status, or perceived abilities (Shulman, 1986). More recent studies demonstrate how society fails schools and teachers (Ashton & Webb, 1986).

The stories of the failures of teachers, students, schools, and American society have become part of our culture, as the parents, teachers, administrators, politicians, religious leaders, and an insatiable broadcast media add to a never ending cycle of anger and blame. Success stories, as few as they are, tell of extraordinary effort, stamina, and personal sacrifice in the face of overwhelming odds (the super-teacher myth). The quiet, ordinary successes that occur in most classrooms, with ordinary teachers and ordinary students, are uninteresting, un-newsworthy. Despite the constant barrage of criticism, or the tales of heroic teachers and mythic classrooms, the best classrooms are those in which ordinary teachers and students, when they go home at the end of the day, can say "Today was a good day" and "I look forward to tomorrow." Efforts and inquiries, directed toward these simple goals, day by day, are the only real basis for hope and renewal. The loss of such hope, for teachers and students, is society's greatest threat.

— 7 —
Instructional Design for Inquiry

*I was talking to an elementary art teacher
the other day who is held in the highest regard
by her school and her students. She was irate. She'd
just come from a conference where
she'd been told once again about what more
she should be doing.*
(Elledna Katan, 1990, p. 61)

This chapter brings together insights derived from perspectives, research findings, and instructional practices discussed throughout this book. Approaches derived from varying models of instructional planning will be reviewed. Teacher-centered and student-centered practices are then compared and discussed with regard to art education practices. Several views of what "good teaching" entails are then offered, and findings from attempts to answer the question, "What do students really want from teachers?" are shared. This chapter concludes with some comments about themes in late-20th-century educational thought.

Schools of Thought

Ralph Tyler's *The Basic Principles of Curriculum and Instruction*, first published at mid-century, set forth an organizational scheme for instructional planning that he termed *rationalism*. For Tyler, such an approach circumvented the debates between groups he termed the "essentialists" (those concerned with subject matter) and the "progressives" (those concerned with children) by including both perspectives in decisions about education goals.

Once goals were selected, instructional planning became a rational process of designing learning encounters to meet educational objectives, utilizing appropriate instructional materials, and evaluating student learning with regard to predetermined objectives. This approach became known as the Tyler Method.

The approach offered by cognitive developmentalists such as Robert Gagne (1985) and Jerome Bruner (1971, 1985) placed the process of instruction planning in the context of psychological principles of learning. This involves three essential procedures: task analysis, the analysis of learning, and structured modeling with guidance. *Task analysis* is the descriptive term given to the process of analyzing complex, multidimensional behaviors for teaching purposes. A task analysis reveals a set of discrete actions (both overt and covert) that must be performed in a step-like fashion to accomplish a complex objective. *Analysis of learning* refers to the attempt to identify and plan for the various components of task completion and skill building. Analysis of learning involves diagnosing prerequisite skills on the part of learners, identifying the steps in acquiring any newly identified skills, selecting training activities, and sequencing activities for effective and efficient learning. *Modeling with guidance* provides learners with live or symbolic demonstrations of new behaviors followed by guided practice and corrective information. In structured modeling with guidance, processes involved in task completion are demonstrated by the teacher or more competent peer, and guided practice is provided until the learner acquires the executive routine, or procedural rules, that govern the task as a whole.

Modeling with feedback works because of the learner's capacity for self-analysis and self-regulation. John Bruer (1994) refers to this approach as *reciprocal teaching*, suggesting a mutual exchange of information between teachers and learners. In *reciprocal teaching* teachers not only model and provide feedback to learners, they also respond to learners' inquiries and actions and modify their instructional behaviors according to learners' responses and capabilities.

A third view, one promulgated by critical theorists and social reconstructionists, focuses attention on the political and moral dimensions of education. In this view, schooling, seen as an agent of culture, has the potential to either maintain the status quo or disrupt and regenerate a new social order — one that is based on personal and communal notions of freedom, democracy, and self-fulfillment (Aronowitz & Giroux, 1988; Gore, 1993). Teaching, in the first case, is involved in the transmission of culture; in the second case, teaching means empowering students as active and critical citizens (Aronowitz & Giroux, 1988). Central to this agenda is a focus on relationships between teach-

ers and students; between teachers and teachers; and between teachers, students, and schools within their larger communities (Ambush, 1993; Bersson, 1987; Blandy & Congdon, 1987; Blandy & Hoffman, 1993; Congdon, 1989; Hicks, 1994; McFee & Degge, 1977). Underlying these relationships are social patterns of social, intellectual, and economic power, and the differential allocation of opportunities and outcomes that exist in the United States (Chalmers, 1992; Collins, 1995; Collins & Sandell, 1984; Freedman, 1994; Hicks, 1990; Sherman, 1982; Sullivan, 1993; Wasson, Stuhr, Petrovich-Mwaiki, 1990). This view has been spurred on by the *feminist* and *multicultural movements* that have gained prominence in recent years. Teaching, in this view, is geared toward a radical social and political change.

Perhaps the most significant change in thinking about educational processes is found in the *constructivist movement*. Constructivist theories of instruction describe student learning in terms of "grasping essences" rather than mastering discrete skills and processes. In this view learning is not seen as the acquisition of knowledge about the world but rather as the construction and re-construction of knowledge in the mind of the knower. Knowledge is understanding and creating meaning for oneself, it is "reinventing the wheel" (O'Niel, 1990), something teachers were once told was a waste of time. Constructing knowledge is also learning how to think. It is thinking about thinking (metacognition), about planning, about goal setting, and about strategies for further inquiry. The processes of thinking and learning, including the processes involved in critical thinking, are now the valued knowledge of society.

Constructivist pedagogies draw from both direct and indirect instructional approaches. But teachers, rather than spending a majority of class time telling, demonstrating, and explaining, instead spend time facilitating individuals or groups of students in problem-solving and independent-research activities. Teachers time their instructions, waiting for student questions to emerge. The content and structure of the lessons are embedded in the materials and activities, rather than delivered directly through lectures and presentations. According to O'Niel (1990), the discovery and learning that take place in constructivist teaching are not random. Teachers still orchestrate learning events, introduce new material, including the field of inquiry's standards for generating useful knowledge, and attempt to enlarge students' understandings. Goals and key concepts are planned for. Memorizing facts and separate practice on discrete skills are necessary at times (O'Niel, 1990). The teacher co-interprets and co-mediates student-learning in-process and guides learners toward the current, best understandings. Responsibility for learning is shared by teacher and student.

Direct or Indirect Instructional Methods?

The differences between direct and indirect teaching have been compared to the differences between telling and asking. Telling is teacher centered, asking is student centered (Davies, 1981). Telling is quicker, more straightforward, and easier. Asking is more time consuming, less direct, and less predictable. The following discussion of these two approaches exemplifies the manner in which current educational discourse correctly and incorrectly favors indirect methods for the construction of engaging and meaningful learning experiences.

Direct teaching includes lecturing, large-group instruction, recitation, demonstrating, coaching, and drill and practice. Although direct methods are potentially effective and powerful tools for teaching, critics observe that in many teacher-centered classrooms students are engaged in a great deal of quiet seat work, discussions in which teachers do almost all of the talking, teacher questioning sessions that requiring little of students beyond the simple recall of factual information, an emphasis on textbooks and published instructional aids, and the use of teacher-made tests and quizzes comprised mostly of multiple-choice questions (Cuban, 1986). High-geared reform efforts aimed at improving the classroom performance of teachers and student performance on standardized tests solidifies the traditional reliance on teacher-centered instruction (Cuban, 1986). Direct instruction is found to be the most efficient way of transmitting the most information (the kind found on standardized tests) to the greatest number of students.

Indirect teaching involves what Carl Rogers (one of the leading figures in humanistic psychology in the 1960s and 1970s) calls *facilitating*. Traditional teaching, for Rogers, stifles student initiative, freedom, self-direction and self-responsibility. In *facilitative teaching* the student takes on many of the duties of the traditional teacher: selecting topics to study, working out procedures, identifying resources, and completing work to his or her own satisfaction. The teacher observes students and talks with them at length. The purpose of this observation and conversation is to help students identify what they want and need to know. The teacher and student, collaboratively, clarify topics to study, procedures for investigating, and needed resources that will make possible identified areas of inquiry. The teacher assists students in securing materials, arranges learning spaces and activities, and participates alongside learners in the investigation. As learning activities progress, the teacher helps students identify the significance of what they are learning, focusing on personal meanings. Evaluation is seen in terms of the meaning and value of the learning activities to the students.

Polarizing instructional approaches is useful only insofar as an examination of the extremes helps clarify the middle ground, where most good teaching will fall. At one extreme, in an approach referred to as didactic teaching, the teacher dominates the classroom in every regard — from the selection and sequencing of instructional activities to the evaluation of student performance. At the other extreme, a laissez-faire approach, all decision making is delegated to students. Despite the undertones that pervade negative characterizations of didactic teaching, the assumption that teachers using indirect methods (discussion, projects, discovery learning) produce a democratic classroom climate and that teachers who rely on direct methods (lecturing, seat work, mastery learning) produce an authoritarian regime is incorrect (Delamont, 1976). Pitfalls exist in self-guided or discovery lesson strategies. First, many self-guided activities are actually highly structured lessons that have been designed by teachers and oriented toward the instrumental aims preselected by teachers; their organizational schemes and goals are embedded (hidden) in the materials and activities students encounter. Second, such strategies require a great deal of student trust (a highly important psychological and emotional factor) in teachers' abilities to implement such lessons. This trust, in effect, places teachers back into the role of authority. Third, not all students fare well in these kinds of learning situations. Some students are intimidated by the chaotic nature of discovery learning and free-wheeling discussion sessions. Their self-confidence and learning are inhibited in such encounters.

Using words like "formal" and "informal" to suggest an optimal strategy for teaching can become a semantic trap. It is wrong to assume that the use of direct or indirect teaching methods, per se, leads to better learning. Students can be productive in formal settings and quite uncomfortable in relaxed climates. Students' social and cognitive needs vary dramatically in different situations.

Toward a Holistic View of Teaching and Learning

During the past 30 years, educators have witnessed the rise and fall of behavioristic and developmental determinism in American public education. At the same time, focus has shifted toward broader philosophical, cultural, and ethical issues. Contemporary initiatives reflect this shift in thinking about teaching, learning, and the purposes of schooling. Table 1 highlights varying views and demonstrates the cyclical nature of thinking about the enterprise of education from an emphasis on the subjective, affective elements of schooling to behavioristic notions of learning and, finally, to a reemerging interest in the personalistic nature of knowledge construction within a meaningful context.

At first glance, recent thinking bears similarities to earlier notions of education, notions aligned with the humanistic psychology espoused by Maslow (1968), Rogers, and their followers in the 1960s. Carl Rogers's facilitative approach, needless to say, was problematic when it was introduced and continues to be problematic today. Serious practical and philosophical questions aside, this approach fills a critical void in educational thinking and practice and may be reconfigured in an approach termed *holistic teaching.* Holistic teaching builds upon research in *cognition and the construction of knowledge,* a contribution credited by Ralph Smith (1987) and others to Jerome Bruner's work. But holistic education is also oriented toward humanistic notions of learning, a concern for the integrity of children's realities, and an interest in thinking about and solving the social problems children face.

Impediments to Change

Despite a theoretical shift toward indirect teaching methods, teacher-dominated approaches and individual seat work by students still make up a good portion of the school day in most classrooms (Ayers, 1991; Johnson, 1981). Cuban (1986) believes that efforts to alter and expand core instructional practices and attempts to move pedagogy toward the use of more student-centered practices are mostly unsuccessful because the organizational structures of schools are not conducive to change. These organizational arrangements govern teacher schedules, allocate time and spaces in schools, and shape how and by whom instructional decisions are made. Reformers seem unaware of the history of teacher-centered instruction as a response to the conditions of their labor: large classes, short periods, little time to evaluate students' work, no time to meet with colleagues. It is not surprising that teachers "have little energy or time during or outside the class to explore ideas with students, to permit students to make errors that can then be reassessed, to listen as students try out new thoughts, question the textbook, or question the teacher's statements" (Cuban, 1986, p. 10).

Cuban argues that the kind of pedagogy needed to enhance students' capabilities and dispositions to reflect, to question, to consider creative solutions to problems, and to gain a grasp of the formulation of problems themselves would require an even greater use of instructional activities which encourage students to exchange ideas and views with teachers and with peers. In Cuban's assessment of the current state of schooling, this will require a significant reallocation of time and setting. Indirect instructional programs are time-consuming, inefficient, and difficult to evaluate. Nor are they likely candidates for sustained support until the current accountability-driven mind-set of poli-

Table 1
Shifts in Thinking About Teaching and Learning

Personalistic Model	Behavioristic Model	Holistic Model
Knowledge		
Subjective, personalistic, child-centered. Authentic knowledge is that which is found to be personally relevant to students	Knowledge lies outside the student and is rule governed. Acquisition of factual information and ability to make applications.	Focus on understanding structures, grasping essences and meanings. Knowledge reconstructed by students
Learning		
Process of growth and development in accordance with nature (natural unfoldment). Learning is innate, activity oriented, self-directed.	Occurs incrementally, from simple to complex, familiar to unfamiliar. Task oriented, drill and practice. Learning viewed as behavior modification.	Learning is holistic, based on multiple cognitive and affective processes. May begin with complex, puzzling, unfamiliar information. Learning as Apprenticeship.
Motivation		
Individuals are active, stimulus seeking, self-directing, self-determining agents.	Learning reinforced by conditioning, including extrinsic rewards.	Learning reinforced by relevance to students' interests and lives.
Purpose of Schooling		
Self-actualization, personal fulfillment. Individuals discover own talents and identities.	Effective and efficient means of transferring information and providing vocational training. Socialization.	Deep understanding. Expanding personal perspective. Solving real-life problems creatively.
Role of the Teacher		
Guide. Attends to needs and interests of students. Provides enjoyable learning experiences. Is not prescriptive or coercive.	Authority. Manager of classroom episodes. Gives information and knowledge. Selects and organizes learning episodes.	Mentor, expert, and role model. One of many sources of information. Facilitates and orchestrates learning environment. Teaching as Reciprocal.

Table 1, *Continued*

Personalistic Model	Behavioristic Model	Holistic Model
Views of the Student		
Regarded as an individual rather than a member of a class. Subjectively free and autonomous, architect of own life.	Receiver of information. Success or achievement commensurate with abilities and efforts.	Maker of own knowledge, needing structured learning experiences with teachers who do not overteach.
Subject Matter		
Emerges out of sympathetic interactions of teachers and students. Determined by student interests.	Subjects distinguished, taught separately. Disciplinary knowledge simplified to basic concepts and principles.	Subjects interrelate. Interdisciplinary, thematic, or problem-centered approach. May be complex from the beginning.
Curriculum Structure		
Unstructured programs. Developed in concert with students rather than predetermined by school bureaucracies.	Linear sequence. Units predetermined and organized hierarchically. Patterned after structures of the academic disciplines.	Fluid or web-like. Interdisciplinary approach. Organized around situations, simulations, and problems.
Assessment of Learning		
Student and process centered. Idiosyncratic, determined according to needs, interests, and abilities of individual students.	Standardized, multiple, single-occasion events. On-demand recall of discrete facts and isolated skills. Teachers as judges.	Authentic simulations of real problems. Individualized, ongoing, curriculum embedded. Students self-judge own work with teacher assistance.

cymakers is broadened to include consideration of the growing body of research that confirms the constructive educational impact of student-student and cooperative learning strategies.

Nevertheless, changes may be observable in the schools. Constructivist theories about learning have strongly influenced the whole language movement in English. Socratic dialogue, hands-on science, and process writing are fairly well accepted instructional practices in some classrooms today. The development of cooperative learning models, the increased use of simulations and game-like formats, and a greater interest in peer discussion groups, peer evaluation, and small-group work on academic tasks and projects foster a climate conducive to students asking their own questions and developing frameworks for sustained inquiry. Independent study, self-directed inquiry, and self-evaluation all encourage more student choice and autonomy. Taken together, these strategies and methods focus on the development of students' reasoning and problem-solving skills, establish links beyond the classroom, and encourage the use of innovative supplementary instructional materials (Cuban, 1986).

Art Education

One could argue that art education instruction has always been based on discovery learning and constructivist principles. But, in reality, most art teachers have relied heavily on direct teaching methods, rigidly prescriptive learning activities, and a conservative view of curriculum content. Art teachers generally limit student explorations to emulating themes and variations of teachers' models of good art (or good practice). The point is not that direct teaching and conservative, prescriptive instructional programs are wrong. Rather, the point is that art education is not as discovery oriented as many claim. It may have been (until recent years) just a little more so than some other subject areas. However, students in art classes mostly work alone at their seats or tables on uncontroversial, teacher-selected and teacher-directed, assignments and projects. Notable exceptions may be found in some advanced studio programs developed for talented upper level high school students, where students select their own problems, media, and themes to explore, or in specialized model programs developed in conjunction with universities and philanthropic foundations, where art classes become, in effect, learning labs for academic research.

Visual arts education, despite all the radical rhetoric, is still dominated by (a) a formalistic aesthetic theory; (b) an emphasis on individualistic studio experiences focused on design concepts and the techniques associated with media

and processes; (c) a highly specialized conceptual framework for perceiving and responding to art; (d) a language structure antithetical to nonpractitioners (Hamblen, 1987); and (e) a disposition toward art objects that ignores intentionality, context, and personal meaning. The description of school art programs as adult-centered and unrelated to the lives and realities of children is not new. The observation that these programs are characterized by colorful displays of student work that reflects more of the aesthetic tendencies of the teachers than the students was made by Arthur Efland (1976) almost 20 years ago.

Recent efforts at developing student-centered learning activities, peer tutoring, constructively managed dialogues on issues in the art world, and authentic art assessment strategies hold great promise for expanding the range of instructional practices available to art teachers. As for the political agenda of social reconstructionism, the field is less certain. Art teachers are primarily concerned with the materials and processes associated with the creation of and response to art and with how to keep their programs from being cut.

No single approach should be seen as "the" way to teach art. Direct teaching, adult-centered notions of knowledge, and the content-centered disciplinary traditions and issues of the adult art world form the basis of sound instructional programs in the visual arts (Clark et al., 1987). At the same time, to ignore the conditions of the world in instructional programs neglects a great deal of art making that has gone on for the last 50 years. It is not an "either-or" case as some would have it. Rather a multifaceted but balanced approach to these questions, whatever that means to individual art teachers, is the best strategy for designing instructional programs. The debates over exactly how and what to teach may not be resolvable, and perhaps this is good. Divergent instructional programs need to be explored and examined.

What is Good Teaching?

Like the debates on approaches to teaching, educated opinions about the most desirable characteristics and behaviors of teachers are also in contention. Brophy (1986) defines good teaching in terms of effective classroom management, the ability to maintain the classroom as an healthy and successful environment for teaching and learning, and student success in learning and achievement. Brophy believes that these levels of success are partly due to the development of good classroom management and instructional skills. Effective teachers share similarities in the manner in which they organize learning encounters and manage classrooms. These similarities follow.

1. *Variety and challenge in individual work.* Effective teachers provide their students with assignments that are meaningful, interesting, varied, and developmentally appropriate. This means that teachers need a firm grasp of subject matter content as well as prior understanding of the abilities and conceptual structures of their students.

2. *Effective procedural and academic instruction.* Successful teachers provide complete instructions and demonstrate how to work through examples of the tasks or problems assigned to students. These teachers install clear procedures governing student behavior during individual work sessions. Students know what they are supposed to accomplish, how, and in what priority; they know when and how to get help and what to do when they are finished, including which free choice options are available to them. Good teachers regularly circulate through the room, checking students' progress and attending to students needing additional help.

3. *"With-it-ness."* Successful teachers continuously monitor their classrooms, positioning themselves where they can see everything going on. These teachers ignore minor, temporary incidents of inattention but respond immediately to disruptive behaviors that appear likely to escalate. Students know when teachers are "with it."

4. *Overlapping.* Successful teachers are able to do more than one thing at a time to keep their classes running smoothly. They can handle routine housekeeping tasks or individual student needs without interrupting the flow of ongoing activities of the class as a whole.

5. *Pacing.* Successful teachers keep the momentum of lessons moving at a brisk pace through careful preplanning prior to instructional episodes. There are no major interruptions to instruction due to failure to bring a prop, confusion about what to do next, false starts, or backtracking.

6. *Prevention.* Successful teachers *systematically* minimize the frequency of inattention and disruption by preventing disruptions from occurring. They spend less time correcting inappropriate behaviors because expectations are clearly set into place at the beginning of the year and monitored consistently throughout the year. When disruptions do occur, these teachers respond to student misconduct in nondisruptive ways, including eye contact, physical proximity (moving closer), directing a question to the student involved, or cueing him or her with a comment. Both teacher and student attention is focused on the content of the lesson and not on lengthy reprimands or other overreactions.

Another View: The Relevance of Teaching

Postman and Weingartner (1969) offer a different description of good teaching. They base their views on the notion that "the beliefs, feelings, and assumptions of teachers are the air of a learning environment; they determine the quality of life within it" (p. 33). For Postman and Weingartner teachers must construct an educational environment that fosters in students a disposition for inquiry, confidence, flexibility, and a tolerance for ambiguity. Such teachers display the kinds of attitudes toward learners and instructional activities outlined in the following descriptions.

1. *Content for study.* Teachers rarely tell students what they think students ought to know, because it deprives students of the excitement of discovery and denies them the opportunity to increase their power as learners. Teachers spend more time listening to what students have to say than talking at students. Their lessons develop from the responses of their students and not from a previously determined logical structure or syllabus.

2. *Instructional methods and lesson planning.* Teachers' primary mode of discourse with students is questioning. Questions are seen as instruments to open engaged minds to unsuspected possibilities. Their lessons pose problems for students. To deal with these problems students must engage in the inductive methods of inquiry (clarifying the problems, making observations relevant to the solution of the problems, and forming/testing generalizations based on those observations).

3. *Teacher response and feedback.* Teachers do not accept single statements as answers to questions, rather they promote all answers as plural and contingent. They rarely summarize positions taken by students, understanding that such acts tend to truncate further thought. Rather student summaries are restated as hypotheses.

4. *Classroom interactions.* Teachers encourage student-student interaction over student-teacher interaction. Student talk is more important than teacher talk.

5. *Evaluation of learning.* Teachers encourage students to develop their own standards for judging the quality, precision, and relevance of ideas.

6. *Program evaluation.* Teachers measure success in terms of behavioral changes in students: the frequency with which students generate their own questions, the increase in the cogency and relevance of those questions,

the frequency and conviction of their challenges to others' assertions, the clarity of the standards on which they base their challenges, their willingness to suspend judgments when they have insufficient data, their willingness to modify their position, their increasing tolerance for diverse views, and their ability to apply generalizations and information to novel situations.

What Do Students Really Want from Us?

Most teachers have a fairly good idea of what they want from students. They want students to become people who can think intelligently and creatively, question critically, communicate clearly and expressively, critique freely, work for the common good, and link consciousness to conduct (Ayers, 1991). But what do students want from teachers? Educational researchers have been asking this question as far back as the 1930s. From those days and continuing into the present, students rank *teaching competence* highest among desired teacher characteristics (Wragg & Wood, 1984). Even so-called nonacademic members of the class value teaching skill and are prepared to learn from those teachers *able to arouse interest*. Wragg and Wood (1984) found that students have a clear and concise understanding of classroom events that often coincides with that of their classmates. Students tend to give similar views of the teachers they discussed with few dissensions. They understand how teachers define or fail to define *rules of behavior*; they know exactly how their teachers will respond in specific situations and often use the exact same words and metaphors as those used by the teachers to describe teachers' expectations and reactions (Wragg & Wood, 1984).

Wragg and Wood found that students want essentially similar things from their teachers. The *ability to explain things clearly* is most highly valued among students, followed by a preference for *interpersonal personal characteristics* (using students' first names, helping slower learners catch up in a nice way, providing a lot of help in every lesson, and being a good listener). Students like teachers who are *firm but fair, consistent, stimulating, interested in individuals, and possessing a sense of humor*. Those teachers who fail to temper their authority with *humanity* (humor and perceived compassion) tend not to secure a positive trusting relationship with their class. Studies on student views of teaching further confirm these notions. These studies indicate that students prefer teacher personal characteristics that include *kindness, friendliness, patience, fairness*, and a *sense of humor*. Nash (1976) found that 12- to 13-year-olds are most concerned with *discipline*, the *ability to teach, explaining ability, degree of interest, fairness*, and *friendliness*. Studies consistently show that students want their teachers to maintain discipline in the classroom.

Students want, it seems, the same things most of us want: the opportunity to learn from those who are knowledgeable, to have order in their lives, to feel secure, and to be regarded well by others.

Some Final Thoughts: Instructional Planning as Design for Inquiry

Contemporary issues in instructional theory and design center around concerns about the nature and function of teaching and learning in schools. These concerns include questions about how students come to know the world they live in and how our society's institutions define and shape human attitudes and interactions with one another. The questions for instructional design and practice in art education today are not simply which projects to do, or whether to implement a discipline-based or multicultural art education, or whose art is most worthy of study. The questions are even more basic than what students should know and be able to do in art as a result of art classes. The questions teachers need to ask are *What kinds of people will create our future?* and *How might teachers construct learning environments with students in such a way as to collectively build that future?* The ways in which an education in the visual arts addresses these questions becomes the focal point for contemporary instructional inquiry, design, and practice.

Teaching is a complex, continual process of decision making, or theory in action, and the students are never static. They are a seething mass of perpetual motion, challenge, and unpredictability. Indeed, complexity, ambiguity, and rapid change characterize the art room, just as they characterize late - 20th- century life. Art educators' best strategy may be to embrace the challenge and complexity of contemporary life and to redefine teaching as the creation of opportunities for meaningful inquiry by students, individually and communally. The notion of teaching as the creation of opportunities for meaningful inquiry means that instruction is centered around *teaching students how to pose their own questions, how to learn and utilize complex thinking processes, how to learn how to learn,* and, finally *how to identify and solve the problems we have created for them.* Instructional activities designed for these ends are deliberately and deservedly distinguished from activities associated with indoctrination, training, brainwashing, and the transmittal of favored aspects of a particular person's cultural heritage. Students need to be better prepared to ask relevant questions and become better problem solvers as, together with their teachers, they face an uncertain future. Instructional design, in this view, becomes a program centered around critical inquiry.

The ideas shared in this book have ranged from the idealistic to the mundane, without apology for either. It is hoped that the perspectives selected for inclusion here will be useful to those art teachers, teacher educators, administrators, or art education policy makers who have an interest in revitalizing art teaching. Planning and preparation, good classroom management skills, effective questioning and discussion methods and strategies, a disposition toward openness and responsiveness to students, a wealth of knowledge, a commitment to reflective self-inquiry and professional growth, and endless patience, faith, hope, and love — these are a few of the essential ingredients of successful teaching, provided educators are teaching something that is worth learning. But that is another book.

— 8 —
References

Addiss, S. & Erickson, M. (1993). *Art history and education*. Urbana: University of Illinois Press.

Alexander, L., Frankiewicz, R. G., & Williams, R. E. (1979). Facilitation of learning of oral instruction using advance and post organizers. *Journal of Educational Psychology, 71*(5), 707-710.

Ambush, D. (1993). Points of intersection: The convergence of aesthetics and race as a phenomenon of experience in the lives of African American children. *Visual Arts Research, 19* (2), 13-23.

Anderson, T. A. (1994). The international baccalaureate model of content-based art education. *Art Education, 47* (2), 19-25.

Armstrong, C. L. (1986). Stages of inquiry in producing art: A model, rationale and application to a teacher questioning strategy. *Studies in Art education, 28*(1), 37-48.

Armstrong, C. L. (1993). Effect of training in art production questioning method on teacher questioning and student responses. *Studies in Art Education, 34*(4), 209-221.

Armstrong, C. L. & Armstrong, N. A. (1977). Art teacher questioning strategy. *Studies in Art Education, 18*(3), 53-64.

Aronowitz, S. & Giroux, H. A. (1988). Schooling, culture, and literacy in the age of broken dreams: A review of Bloom and Hirsch. *Harvard Educational Review, 58*(2), 172-194.

Ashton, P. & Webb, R. (1986). *Making a difference: Teachers' sense of efficacy and student achievement*. White Plains, NY: Longman.

Ayers, W. (1991). *So far, radical rhetoric, conventional classrooms. Catalyst (Voices of Chicago school reform) 11* (8). Chicago: Chicago City Schools.

Bandura, A. & Schunk, D. H. (1981). Cultivating competence, self-efficacy, and intrinsic interest through proximal self-motivation. *Journal of Personality and Social Psychology, 41*(3), 586-598.

Barrett, T. (1991). Description in professional art criticism. *Studies in Art Education, 32*(2), 83-92.

Barrett, T. (1992). Criticizing art with children. In A. Johnson (Ed.), *Art Education: Elementary* (pp. 115-130). Reston, VA: National Art Education Association.

Battin, M. P., Fisher, J., Moore, R., & Silvers, A. (1989). *Puzzles about art*. New York: St. Martin's Press.

Berger, R. (1991). Building a school culture of high standards: A teacher's perspective. In V. Perrone (Ed.), *Expanding student assessment* (pp. 32-39). Alexandria, VA: Association for Supervision and Curriculum Development.

Bersson, R. (1987). Why art education is neither socially relevant nor culturally democratic. In D. Blandy & K. Congdon (Eds.), *Art in a democracy* (pp. 78-90). New York: Teachers College Press.

Blandy, D. & Congdon, K. G. (1987). *Art in a democracy*. New York: Teachers College Press.

Blandy, D. & Hoffman, E. (1993). Toward an art education of place. *Studies in Art Education, 35*(1), 22-33.

Bloom, B. S. (1956/1987). *Taxonomy of educational objectives: Book 1, the cognitive domain*. New York: Longman.

Bowers, C. A. (1987). *Elements of a post-liberal theory of education*. New York: Teachers College Press.

Brewer, T. & Colbert, C. (1992). The effect of contrasting instructional strategies on seventh grade students' ceramic vessels. *Studies in Art Education, 34*(1), 18-27.

Brophy, J. (1983a). Classroom organization and management. *The Elementary School Journal, 83*(4), 265-285.

Brophy, J. (1983b). Conceptualizing student motivation. *Educational Psychologist, 18*(3), 200-215.

Brophy, J. (1986). Classroom management techniques. *Education and Urban Society, 18*(2), 182-194.

Brophy, J. (1987). Synthesis of research on strategies for motivating students to learn. *Educational Leadership, 45*(2), 40-48.

Brophy, J. (1988). Teacher influences on student achievement. *American Psychologist, 41*(10), 1069-1077.

Bruner, J. S. (1960). *The process of education*. Cambridge, MA: Harvard University Press.

Bruner, J. S. (1971). *Toward a theory of instruction*. Cambridge, MA.: Harvard University Press.

Bruner, J. S. (1985). Vygotsky, a historical and conceptual perspective. In J, V. Wertsch (Ed.), *Culture, communication, and cognition: Vygotskyian perspectives*. Cambridge, Great Britain: Cambridge University Press.

Bullock, A. L. & Galbraith, L. (1992). Images of art teaching: Comparing the beliefs and practices of two secondary art teachers. *Studies in Art Education, 33*(2), 86-97.

Calderhead, J. (1984). *Teachers' classroom decision-making*. New York: Holt, Rinehart and Winston.

Chalmers, F. G. (1992). The origins of racism in the public school art curriculum. *Studies in Art Education, 33*(3), 134-143.

Chapman, L. H. (1978). *Approaches to art in education*. New York: Harcourt Brace Jovanovich.

Chapman, L. H. (1982). *Instant art, instant culture: The unspoken policy for American schools*. New York: Teachers College Press.

Charles, C. M., West, D. K., Servey, R. E., & Burnside, H. M. (1978). *Schooling, teaching, and learning: American education*. Saint Louis: The C. V. Mosby Company.

Clark, G. A., Day, M. D., & Greer, W. D. (1987). Discipline-based art education: Becoming students of art. *Journal of Aesthetic Education 28*(2), 129-196.

Collins, G. (1995). Explanations owed my sister: A reconsideration of feminism in art education. *Studies in Art Education, 36*(2), 69-83.

Collins, G. & Sandell, R. (1984). *Women, art, and education*. Reston, VA.: National Art Education Association.

Congdon, K. G. (1989). Multicultural approaches to art criticism. *Studies in Art Education, 30*(3), 176-184.

Cuban, L. (1986). Persistent instruction: Another look at constancy in the classroom. *Phi Delta Kappan, 68*(1), 7-11.

Davies, I. K. (1981). *Instructional technique*. New York: McGraw Hill.

Dawson, P. (1984). *Teachers and teaching*. Oxford, England: Basil Blackwell Limited.

Day, M. D. (1976). The effects of instruction on high school students' art preferences and art judgements. *Studies in Art Education, 18*(1), 25-39.

Delamont, S. (1976). *Interaction in the classroom*. London: Methuen.

Dennison, G. (1969). *The lives of children: The story of the First Street School*. New York: Random House.

Dewey, J. (1916). *Democracy and education, an introduction to the philosophy of education*. New York: Macmillan.

Dewey, J. (1934). *Art as experience*. New York: Putnam.

Doyle, W. (1986). Classroom organization and management. In M. Wittrock (Ed.), *Third handbook of research on teaching* (pp. 392-432). New York: Macmillan.

Edwards, D. & Mercer, N. (1987). *Common knowledge: The development of understanding in the classroom.* New York: Methuen.

Efland, A. D. (1976). The school art style: A functional analysis. *Studies in Art Education, 17*(2), 37-43.

Englemann, S., & Carmine, D. (1982). *Theory of instruction.* New York: Irvington.

Erickson, M. (1983). Teacher talk: Teaching art history as inquiry process. *Art Education, 36*(5), 28-31.

Erickson, M. (1994). Evidence for art historical interpretation referred to by young people and adults. *Studies in Art Education, 35*(2), 71-78.

Feldman, D. H. (1985). Beyond universals in cognitive development. Norwood, NJ: Ablex.

Feynman, R. (1988). Richard Feynman. In P. C. Davies & J. Brown, *Superstrings: A theory of everything?* (pp. 192-210). Cambridge, Great Britain: Cambridge University Press.

Fielding, R. (1989). Socio-cultural theories of cognitive development: Implications for teaching in the classroom. *Art Education, 42*(4), 44-47.

Fitzpatrick, V. L. (1992). Art history: A contextual inquiry course. Reston, VA: National Art Education Association.

Freedman, K. (1994). Interpreting gender and visual culture in art classrooms. *Studies in Art Education, 35*(3), 157-170.

Gagne, R. M. (1985). *The conditions of learning* (4th ed.). New York: Holt, Rinehart and Winston.

Gardner, H. (1993). *Multiple intelligences: The theory in practice.* New York: Basic Books.

Giroux, H. A., Penna, A. N., & Pinar, W. F. (1981). *Curriculum and instruction: Alternatives in education.* Berkeley, CA: McCutchan.

Good, T. & Brophy, J. (1978). *Looking in classrooms* (2nd ed.). New York: Harper & Row.

Gore, J. M. (1993). *The struggle for pedagogies.* New York: Routledge.

Gorman, A. (1974). *Teachers and learners: The interactive process of education* (2nd ed.) Boston: Allyn and Bacon.

Gray, J. (1992). An art teacher is an art teacher is an art teacher ... fortunately! *Art Education, 45*(4), 19-23.

Green, T. (1974). *The activities of teaching.* New York: McGraw Hill.

Greer, D. W. (1987). A structure of discipline concepts for DBAE. *Studies in Art Education, 28*(4), 227-233.

Grigsby, J. E. (1977). *Art and ethnics: Background for teaching youth in a pluralistic society.* Dubuque, IA: William C. Brown.

Hagaman, S. (1990b). Philosophical aesthetics and art education: A further look toward implementation. *Art Education, 43*(4), 22-24, 33-39.

Hagaman, S. (1990a). The community of inquiry: An approach to collaborative learning. *Studies in Art Education 31*(3), 149-157.

Hagaman, S. (1992). Aesthetics in elementary art education. In A. Johnson (Ed.), *Art education: Elementary* (pp. 105-114). Reston, VA: National Art Education Association.

Hamblen, K. A. (1984). An art criticism questioning strategy within the framework of Bloom's taxonomy. *Studies in Art Education, 26*(1), 41-50.

Hamblen, K. A. (1986). Exploring contested concepts for aesthetic literacy. *Journal of Aesthetic Education, 20*(2), 67-77.

Hamblen, K. A. (1987). Beyond universalism in art criticism. In D. Blandy & K. G. Congdon (Eds.), *Pluralistic approaches to art criticism* (pp. 7-14). Bowling Green, OH: Bowling Green State University Popular Press.

Hamblen, K. A. (1988). If it is to be tested, it will be taught: A rationale worthy of examination. *Art Education, 41*(5), 59-62.

Hart, L. M. (1991). Aesthetic pluralism and multicultural art education. *Studies in Art Education, 32*(3), 145-159.

Henley, D. (1991). Affective expression in post-modern art education: Theory and intervention. *Art Education, 44*(2), 16-22.

Hicks, L. (1990). A feminist analysis of empowerment and community in art education. *Studies in Art Education, 32*(1), 36-46.

Hicks, L. (1994). Social reconstruction and community. *Studies in Art Education, 35*(3), 149-156.

Hollingsworth, P. L. (1983). The combined effect of mere exposure, counterattitudinal advocacy, and art criticism methodology on upper elementary and junior high students' affect toward art works. *Studies in Art Education, 24*(2), 101-110.

Hurwitz, A. & Madeja, S. (1976). *The joyous vision: Art appreciation for the elementary school.* New York: Van Nostrand Reinhold.

Jackson, P. W. (1968). *Life in the classrooms.* New York: Holt, Rinehart, & Winston.

Johnson, D. W. (1981). Student-student interaction: The neglected variable in education. *Educational Researcher, 10*(1), 5-10.

Joyce, B. & Weil, M. (1980). *Models of teaching,* (2nd ed.). Englewood Cliffs, NJ: Prentice-Hall.

Katan, E. (1990). Beyond ART HISTORY ... and before. ... and beyond ... and before.. *Art Education, 43*(1), 60-69.

Katter, E. (1988). An approach to art games: Playing and planning. *Art Education, 41*(3), 46-48, 50-54.

Koroscik, J. S. (1982). The effects of prior knowledge, presentation time, and task demands on visual art processing. *Studies in Art Education, 23*(3), 13-22.

Koroscik, J. S. (1985). The effect of verbalization in understanding visual art. *Arts and Learning, 3*(1), 127-133.

Koroscik, J. S., Short, G., Stavropoulos, C., & Fortin, S. (1992). Frameworks for understanding art: The function of comparative contexts and verbal cues. *Studies in Art Education, 33*(3), 154-164.

Lamm, Z. (1976). *Conflicting theories of instruction.* Berkeley, CA: McCutchan.

Lankford, E. L. & Mims, S. K. (1995). Time, money, and the new art education: A nationwide investigation. *Studies in Art Education, 36*(2), 84-95.

Lankford, E. L. (1992). *Aesthetics: Issues and inquiry.* Reston, VA: National Art Education Association.

Laslett, R., & Smith, C. (1984). *Effective classroom management: A teacher's guide.* New York: Nicolas Publishing.

Leeds, J. A. (1989). History of attitudes toward children's art. *Studies in Art Education, 30*(2), 93-103.

Leonhard, C. (1991). *Status of arts education in American Schools* (Report on a survey conducted by the National Arts Education Research Center). Urbana, IL: Council for Research in Music Education.

Levine, J. (1989). *Secondary instruction: A manual for teaching.* Boston: Allyn and Bacon.

Lipman, M., Oscanyan, F. S., & Sharp, M. A. (1980). *Philosophy in the classroom.* Philadelphia: Temple University Press.

Lowenfeld, V. & Brittain, W. L. (1964) *Creative and mental growth* (2nd ed.). New York: Macmillan.

Maslow, A. H. (1968). *Toward a psychology of being.* New York: Reinhold.

Matthews, G. (1984). *Dialogues with children.* Cambridge, MA: Harvard University Press.

May, W. T. (1994). The tie that binds: Reconstructing ourselves in institutional contexts. *Studies in Art Education, 35*(3), 135-148.

May, W. T. (1989). Teachers, teaching and the workplace: Omissions in curriculum reform. *Studies in Art Education, 30*(3), 142-156.

McCutcheon, G. (1981). On the interpretation of classroom observations. *Educational Researcher,* May 1981, 5-10.

McFee, J. K. & Degge, R. (1977). *Art, culture, and environment: A catalyst for teaching.* Belmont, CA: Wadsworth.

McLaughlin, M. & Thomas, M. (1985). *Art history, art criticism, and art production: An examination of art education in selected school districts.* Los Angeles: Rand Corporation.

Mims, S. K., & Lankford, E. L. (1994). The new art education and what we've learned from superwoman. *Art Education, 47*(3), 57-61.

Nasbitt J. & Aburdene, P. (1990). *Megatrends 2000: Ten new directions for the 1990s.* New York: Avon.

National Endowment for the Arts. (1988). *Toward civilization: A report on arts education.* Washington, DC: U. S. Government Printing Office.

O'Niel, J. (1991). Wanted: Deep understanding, 'Constructivism' posits new conception of learning. *ASCD UpDate, 34*(3), 4-8.

Parsons, M. J. (1987). *How we understand art, a cognitive developmental account of aesthetic experience.* Cambridge, Great Britain: Cambridge University Press.

Persell, C. H. (1993). Social class and educational equality. In J. A. Banks & C. A. McGee Banks (Eds.), *Multicultural education: Issues and perspectives* (pp. 71-79). Boston: Allyn and Bacon.

Platten, M. (1991, March). Teaching concepts and skills of thinking simultaneously. Paper presented at the annual conference of the National Art Education Association.

Postman, N. & Weingartner, C. (1969). *Teaching as a subversive activity.* New York: Delacorte Press.

Rosenshine, B. & Stevens, R. (1986). *Teaching functions. Third handbook of research on teaching* (pp. 376-391). New York: Macmillan.

Rosenthal, R. & Jacobson, L. (1968). *Pygmalion in the classroom: Teacher expectation and pupil's intellectual development.* New York: Holt, Rinehart, & Winston.

Roukes, N. (1988). *Design synectics.* Worcester, MA: Davis.

Sandell, R. (1991). The liberating relevance of feminist pedagogy. *Studies in Art Education, 32*(3), 178-187.

Scheffler, I. (1965). Philosophical models of teaching. *Harvard Educational Review, 35*(2), 131-143.

Shavelson, R. J. & Stern, P. (1981). Research on teachers' pedagogical thoughts, judgements, decisions, and behavior. *Review of Educational Research, 51*(4), 455-498.

Sherman, A. (1982). Questions that those concerned with non-sexist art education should ask. *Art Education, 35*(3) 26-29.

Shulman, L. S. (1986). *Paradigms and research programs in the study of teaching. Third handbook of research on teaching* (pp. 6-36). American Educational Research Association.

Slavin, R. E. (1990). Learning together. *The American School Board Journal, 177*(8), 22-23.

Slavin, R. E. (1987). Developmental and motivational perspectives on cooperative learning: A reconciliation. *Child Development, 58,* 1161-1167.

Smith, R. A. (1987). The changing image of art education: Theoretical antecedents of discipline-based art education. *Journal of Aesthetic Education, 21*(2), 3-34.

Stewart, M. (1991a). *Great debates.* In the *Teachers' handbook of the Florida Institute for Art Education.* Tallahassee: Art Education Department, Florida State University.

Stewart, M. (1991b). Thinking and talking about art: Teaching criticism and aesthetics in the middle school. In R. Brooks (Ed.), *Inside art: Annotated teacher's edition* (pp. 35-45). Austin, TX: W. S. Benson & Co.

Stokrocki, M. (1988). Teaching preadolescents during a nine week sequence: The negotiator approach. *Studies in Art Education, 30*(1), 39-46.

Stokrocki, M. (1990a). A cross-site analysis: Problems in teaching art to preadolescents. *Studies in Art Education, 31*(2), 106-117.

Stokrocki, M. (1990b). Forms of instruction used by art teachers with preadolescents. In B. E. Little (Ed.), *Secondary art education: An anthology of issues* (pp 35-46). Reston, VA: National Art Education Association.

Stout, C. (1992). Critical thinking and micro-writing in art appreciation. *Visual Arts Research, 18*(1), 57-71.

Sullivan, G. (1989). Curriculum in art education: The uncertainty principle. *Studies in Art Education, 30*(4), 225-236.

Sullivan, G. (1993). Art-based art education: Learning that is meaningful, authentic, critical, and pluralist. *Studies in Art Education, 35*(10), 5-21.

Susi, F. (1989). The physical environment of art classrooms: A basis for effective discipline. *Art Education, 42*(4), 37-43.

Szekely, G. (1988). *Encouraging creativity in art lessons.* New York: Teachers College Press.

Tyler, R. (1949). *Basic principles of curriculum and instruction.* Chicago: University of Chicago Press.

Wasson, R. F., Stuhr, P. L., & Petrovich-Mwaniki, L. (1990). Teaching art in the multicultural classroom: Six position statements. *Studies in Art Education, 31*(4), 234-246.

West, C., Farmer, J. A., & Wolff, P. M. (1991). *Instructional design: Implications from cognitive science.* Boston: Allyn and Bacon.

Wertsch, J. V. (1985). *Vygotsky and the social formation of mind.* Cambridge, MA.: Harvard University Press.

Wiggins, G. P. (1993). *Assessing student performance: Exploring the purposes and limits of testing.* San Francisco: Jossey-Bass.

Wilson, B. (1966). An experimental study designed to alter fifth and sixth grade students' perception of paintings. *Studies in Art Education, 8*(1), 33-41.

Wilson, B. (1972). The relationship between years of art education training and the use of aesthetic judgement criteria among high school students. *Studies in Art Education, 13*(2), 34-43.

Wilson, B., & Wilson, M. (1981). The use and uselessness of developmental stages. *Art Education, 34*(5), 4-6.

Wilson, B. (1988). *Art education, civilization and the 21st century: A researcher's reflections on the National Endowment for the Arts' report to Congress.* Reston, VA: National Art Education Association.

Wlodkowski, R. J. (1984). *Motivation and teaching.* Washington, DC: National Education Association.

Wolf, D. P. (1988). Opening up assessment. *Educational Leadership, 45*(4), 24-29.

Wolf, D. P. (1987). The art of questioning. *Academic Connections* (Winter 1987). The College Board.

Wragg, E. C. & Wood, P. (1984). *Classroom teaching skills.* New York: Nicolas Publishing.

Zessoules, R, & Gardner, H. (1991). Authentic assessment: Beyond the buzzword and into the classroom. In V. Perrone (Ed.) *Expanding student assessment* (pp. 47-7). Alexandria, VA: Association for Supervision and Curriculum Development.

Zimmerman, E. (1984). What art teachers are not teaching, art students are not learning. *Art Education, 37*(4), 12-15.

Zimmerman, E. (1990). Preparing to teach art to secondary students from all cultural backgrounds. In B. E. Little (Ed.), *Secondary art education: An anthology of issues* (pp. 185-200). Reston, VA: National Art Education Association.

Zurmuehlen, M. (1990). *Studio art: Praxis, symbol, presence.* Reston, VA: National Art Education Association.